Dresden Rüstkammer

The Electoral Wardrobe

Dresden Rüstkammer

The Electoral Wardrobe

Published by Staatliche Kunstsammlungen Dresden

Jutta Charlotte von Bloh
With contributions from Christine Nagel, Viktoria Pisareva,
Marius Winzeler

Deutscher
Kunstverlag

Staatliche
Kunstsammlungen
Dresden

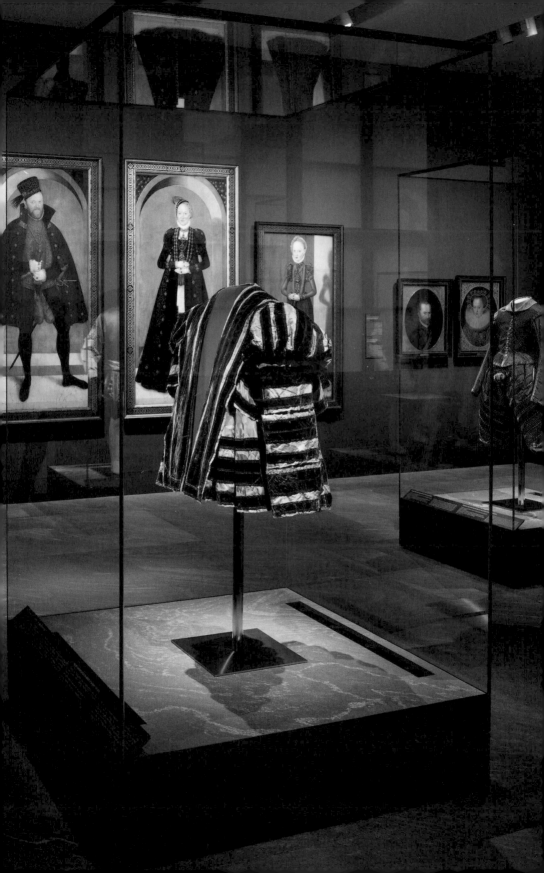

Content

The Rüstkammer (Armoury) in Dresden's Residenzschloss

MARIUS WINZELER

With its magnificent weapons, sumptuous costumes, and lavish accoutrements designed for banqueting and hunting, war and peace, at the Renaissance and Baroque Saxon court, the Dresden Rüstkammer highlights unique facets of the history of Saxony, Europe, and the world. Along with the Münzkabinett, it is the oldest collection of the Staatliche Kunstsammlungen Dresden and bears unrivalled testimony to the dynastic tradition of the Saxon ruling house.

In the reign of Duke Georg the Bearded, who made Dresden his main residence in the early 16th century, there was already a "Herzogliche Harnischkammer" (Ducal Armour Chamber) in the palace. In 1567, Elector August had the first complete inventory of the "Rüst- und Harnischkammer" (Arms and Armour Chamber) drawn up. Starting in 1586, Elector Christian I had the "New Stable Building" constructed to house the growing Electoral collection. This opulent complex accommodated 128 horses for the Elector's personal use, and the precious holdings of the Rüstkammer were stored in numerous 'chambers' inside the building. No fewer than seven rooms were used to store clothing and props for courtly entertainments and tournaments, since the Rüstkammer was responsible for supplying equipment for such festivities. In 1711, August the Strong ordered that the costumes worn by members of the ruling house, hitherto stored in the Electoral Court Tailors' Workshop, should be incorporated into the collection.

The collection was first displayed in museum form – under the name "Königliches Historisches Museum" (Royal Historical Museum) – when it was merged with the holdings from the dissolved Kunstkammer and transferred to the Zwinger in 1832. In 1877, the collection returned to the original Stable Building, now the Johanneum, where it remained until the Second World War. The holdings, which had been removed for safe-keeping during the war, were taken to the Soviet Union in 1945 and were returned in 1958. Between 1959 and 2012, a part of the collection, which resumed its original name of "Rüstkammer" in 1992, were exhibited in the Semper Building of the Zwinger.

The reconstruction of the Residenzschloss, which began in 1986, has enabled the museum to return to its place of origin. Now it can once again present itself as one of the world's foremost collections of historical arms and costumes. In 2010, the "Türckische Cammer" (Turkish Chamber) was inaugurated, and in 2013, the "Riesensaal"

(Hall of the Giants) – restored to its original dimensions but interpreted in a modern way – opened with tournament scenes and prestigious parade armour. In 2016, the exhibition in the Georgenbau, entitled "Kunstkammer – Weltsicht und Wissen um 1600" (Kunstkammer – Concept and Encounter: The World around 1600), was the first part of the collection to move into the Renaissance wing of the Residenzschloss. It presents masterpieces dating from the 15th to the 17th centuries. This was followed in 2017 by the opening of two more permanent exhibitions of the Rüstkammer under the joint title of "Power and Fashion", which cover an area of 1,113 m² and were designed by "Peter Kulka Architektur".

The first of these, "Auf dem Weg zur Kurfürstenmacht" (On the Way to Electoral Power), focuses on the emergence of the Electorate of Saxony as one of the most important states in the Holy Roman Empire. The second, the "Kurfürstliche Garderobe" (Electoral Wardrobe), presented in four rooms in the north wing of the palace, is one of the undisputed highlights of the Dresden art collections: For the first time since the Second World War, one of the world's most important collections of Renaissance and early Baroque costumes is once again on permanent display. Since 2019, the costumes of August the Strong, Elector of Saxony and King of Poland, have been presented as the "Royal Wardrobe" in the State Apartments on the second floor of the west wing.

The "Electoral Wardrobe" could not have come into being without the tireless commitment of many experts over a period of decades. Above all, I would like to thank the long-time Senior Curator of the Rüstkammer, Jutta Charlotte von Bloh, for her diligent work, along with Viktoria Pisareva and Christine Nagel. During the tenure of Dirk Syndram, former Director of the Grünes Gewölbe and the Rüstkammer, it was possible to enlist the support and cooperation of numerous institutions and restorers. Two painstaking and costly restoration projects were undertaken by the Abegg-Stiftung in Riggisberg, Switzerland, who generously donated this work to the Staatliche Kunstsammlungen Dresden. The costume figurines, individually made by Anja Ackermann and Christiane Pfannenberg, highlight the specific style and wealth of detail on the princely garments. The exhibition was brought to fruition by the team of the Rüstkammer and, in particular, its restoration workshop headed by Andreas Frauendorf.

The exhibition of costumes worn by the Electors of Saxony gives due prominence to a cultural treasure of international significance and makes it accessible to visitors from all over the world.

The Electoral Wardrobe in the Dresden Rüstkammer

JUTTA CHARLOTTE VON BLOH

The Dresden Rüstkammer holds a unique collection of lavish costumes dating from the sixteenth to the eighteenth centuries, which were personally worn by the Electors of Saxony. These original garments demonstrate the sumptuousness of princely fashion during the Renaissance and Baroque periods, which can otherwise only be seen in portraits of the major rulers of that era. The known provenance, outstanding craftsmanship, and artistic quality of these textiles, as well as their dynastic significance and international connections, along with the fact that whole ensembles have survived in an impressive state of preservation, mean that the parade garments preserved in Dresden bear unique testimony to the fashions of the early modern period and are thus an essential component of European cultural heritage.

With its extraordinary collection of princely costumes, the Dresden Rüstkammer ranks as one of the most important European collections of its kind, alongside the Rosenborg Palace in Copenhagen and the Livrustkammaren in Stockholm, whose princely and courtly vestments derive from the Danish and Swedish royal families. The princely garments of the Dresden Rüstkammer, which were evacuated for safe-keeping during the Second World War and were thereafter preserved in the museum's storerooms, rarely being exhibited, are

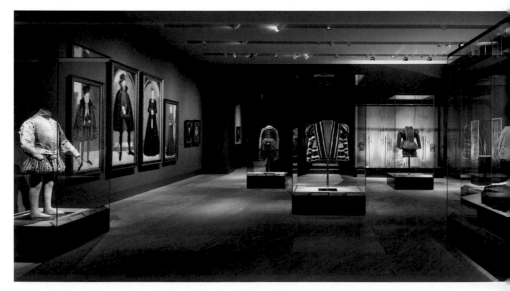

Permanent exhibition of the "Electoral Wardrobe", view of Room I

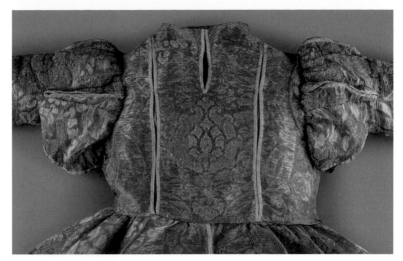

Bridegroom's costume worn by Duke August of Saxony at his wedding to Anna of Denmark in Torgau in 1548, doublet, front view, detail, Rüstkammer, inv. no. i. 0004 (→ showcase 6)

now finally accessible to the public again following the rebuilding of the Dresden Residenzschloss and its reconception as a museum. The costumes preserved from the reigns of Electors Moritz to Johann Georg I between about 1550 and 1650 are now on show in the "Electoral Wardrobe", which opened in 2017; the garments left behind in 1733 by August the Strong, Elector of Saxony and King of Poland, are displayed in the exhibitions entitled "Royal Wardrobe" and "Royal Insignia", which opened in 2019.

The collection of electoral costumes in Dresden goes back to Elector August of Saxony who, after the death of his brother Moritz, the first Elector of Saxony from the Albertine line of the House of Wettin, had the latter's preserved items of clothing recorded in an inventory in 1553. Several generations of Electors followed his example. The desire to preserve and oversee the princely garments was due to their extraordinary dynastic and material value. Hence, the Electoral Court Tailors' Workshop, where the clothes were kept, was simultaneously a place of historiography – preserving something of the personal aura of their owners and commemorating events at which they were worn – and a textile treasure chamber. The name Garderobe (Wardrobe), borrowed from French, which only gained currency at the Dresden Court during the reign of Johann Georg II as a designation for the place where the garments were kept, as well as for the costumes themselves, reflects the priority of taking care of these precious items.

The initial system used for drawing up the clothing inventories in the sixteenth century was based on the hierarchy of materials and garments according to their value and prestige as laid down in the

state regulations on dress code. Among the fabrics, it was the patterned silks with gold and silver woven into them that were most highly prized; among the furs, it was ermine and sable; and among the garments, it was the surcoat. The increasing lavishness of clothing, which took off meteorically in the sixteenth century as the economy expanded, is evident in the growing quantity of garments, their differentiation and number of layers, as well as in the variety of garment types and the diversity of cuts, colours, fabrics, and embroidery. The value of the ensembles of recorded garments increased correspondingly. The value of garment ensembles consisting of several items of clothing was expressed at the time by the term "Kleid" (dress), which was used in the old inventories and descriptions of court festivities to refer to both men's and women's clothing.

For the privileged classes, specific garments came to be worn for different activities, occasions, and stages of life: ceremonial costumes (electoral regalia), clothes for festive occasions, wedding outfits, military uniforms, hunting garments, national dress, masquerade costumes, tournament gear, domestic clothes, sleepwear, bathing clothes, winter garments, rainwear, children's clothes, clothes for old age, mourning dress, and burial clothes. Even Elector August, known for his careful budgeting, possessed extremely luxurious items of clothing.

The value of the clothes was further enhanced by thousands of precious ornaments sewn onto them in the form of buttons, pins, decorative figures, clasps, and buckles. Made of gold, enamel, precious stones, and rock crystal, hundreds of them could be found on a single garment. Eloquent motifs such as hearts, joined hands, or initials, made reference to specific individuals. In the seventeenth century, there was a marked increase in the number and varieties of accessories. New garments were accompanied by matching hats, hatbands, hat cords, sashes, belts, sword hangers, gloves,

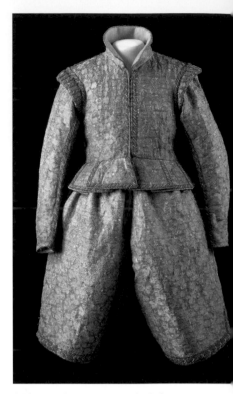

Bridegroom's costume worn by Duke Johann Georg (I) of Saxony at his wedding to Sibylla Elisabeth of Württemberg in Dresden in 1604, Rüstkammer, inv. no. i. 0015

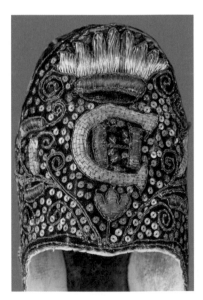

Bridal slippers worn by Princess Hedwig of Denmark at her wedding to Elector Christian II of Saxony in Dresden in 1602, Rüstkammer, inv. no. i. 0104 (→ showcase 19)

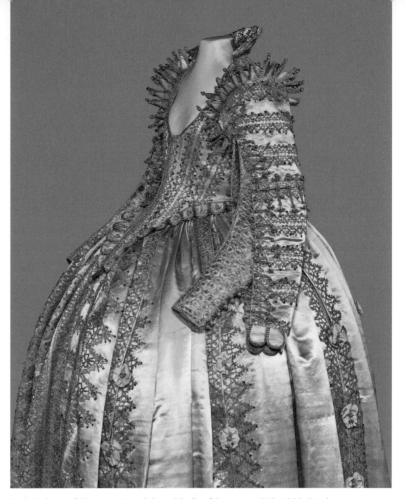

Parade dress of Electress Magdalena Sibylla of Saxony, c. 1610–1620, Rüstkammer, inv. no. i. 0045 (→ showcase 24)

stockings, knee roses, knee bands, shoes, and shoe roses – not infrequently in several versions. This development was coupled with a frenzy of colour and the exuberant use of lace, trimmings, and bows. Fashionable cuts were accentuated by golden borders along the edges and seams.

In accordance with the dynastic reasons for preserving princely attire, the Dresden costume collection consists mainly of men's clothing. The dresses of Electress Magdalena Sibylla, wife of Johann Georg I, therefore stand out all the more: as surviving original examples of seventeenth-century princely ladies' fashions, they are unique on account of their completeness. From the reign of Elector Moritz to that of Johann Georg I, a total of 27 costumes – six complete costume ensembles, eleven sets of doublet and breeches, four ladies' dresses, and six individual upper body garments – have survived from among the hundreds that once existed. The majority of them are completely unique and therefore, with their original cut, workmanship, and

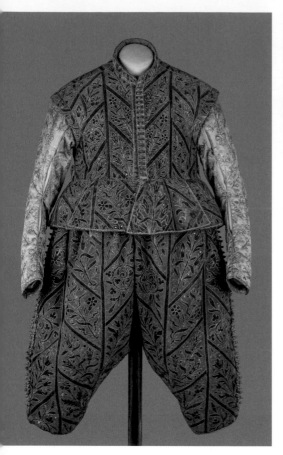

Parade dress of Elector Johann Georg I of Saxony, c. 1616–1620, Rüstkammer, inv. no. i. 0013

Parade dress of Elector Johann Georg I of Saxony, 1615, Rüstkammer, inv. no. i. 0016

technical details, they are key objects for the study of European fashion and textile art of the Renaissance and early Baroque. The display of princely textile outfits is complemented by fashion accessories and luxurious civilian horse equipment.

The textiles used on the garments, saddles, and accessories – gold and silver brocade, silk velvet, silk damask, and silk satin featuring subtle colours and patterns; embroidery in gold, silver, coloured silk, and pearls; gold and silver bobbin lace; and gold and silver trimmings in the form of borders and buttons – bear compelling testimony to the surge of innovation taking place in the gold and silk trades and the rapid development and exquisite craftsmanship of fashion at the beginning of the early modern period. What we see here are first-rate works of European textile art from that era. Their extraordinarily high standard results from the prominent status of their owners as Electors of the Holy Roman Empire, who benefited from dynastic and diplomatic connections to the leading rulers of the time, for example the imperial house, the Danish royal house, and

the Medici in Florence. The precious fabrics and the exquisite, oriental-influenced woven patterns, as well as the colourful embroidery threads, mostly came from Italy. The stylistic influences were primarily from Italy and Spain. In addition, fashion ideas from France, England, and Denmark were taken up. With bobbin lace in gold and silver, pearl, pictorial, and twine embroidery, woollen cloth and linings made of (imported) cotton and linen, the garments also bear witness to indigenous German and Saxon textile production.

In the early modern period, sumptuous costumes and ceremonial weapons were inextricably connected, both being manifestations of princely fashion. That is why the most precious swords and daggers personally worn by the rulers, which are among the holdings of the Rüstkammer, are exhibited along with the princely costumes in the "Electoral Wardrobe". The hunting garments are thus displayed alongside equally luxurious sets of hunting weapons. The weapons on show are decorated with an extraordinary abundance of silver, gold, enamel, rock crystal, pearls, and precious stones of various kinds. They again emphasise the character of the exhibition rooms of the "Electoral Wardrobe" as a treasure chamber of the highest order. Portraits of the Electors and the electoral family additionally illustrate the princely fashion of the time and provide a face for the garments on display.

The history of the costume collection in the Dresden Rüstkammer

CHRISTINE NAGEL

The Electoral Tailors' Workshop (Kurfürstliche Schneiderei) 1553–1711

Duke Moritz of Saxony chose Dresden as his main residence in 1541 and, after gaining the electoral dignity in 1547, had the existing castle converted into a prestigious residence. The Electoral Court Tailor's Workshop was located on the ground floor, in the north-east corner tower and the adjoining rooms of the north wing. These rooms provided working space for the court tailors and for storing and maintaining the finished garments, while the stocks of fabric, trimmings, lace, and sewing material were kept in the vaulted cloth storeroom. This was also the place where tapestries were held. The foundations of the Electoral costume collection were laid when the ruler himself decided to have the clothes he no longer wore put into storage there.

Following the death of Elector Moritz in the Battle of Sievershausen in 1553, his brother and successor Elector August had an inventory drawn up of the deceased's garments that were in storage in the Electoral Court Tailors' Workshop, as well as a list of his own clothing. Further inventories were compiled during August's lifetime, and these document the growth of the collection. The emphasis on the dynastic principle found expression in the fact that, apart from a few ladies' and children's garments worn by members of Johann Georg I's family, only the male ruler's clothing was preserved and inventoried.

The tradition of the ruler keeping and documenting not only his own garments but also those worn by his ancestors, was continued until the second half of the seventeenth century. The various costume inventories document not only the growth of the collection but also provide information about the occasion for which a specific costume was created, and which Elector wore it. From the reign of Elector Johann Georg II onwards, there was an additional storage place for clothing apart from the Electoral Tailors' Workshop, namely the Wardrobe (Garderobe). This was used for storing the garments currently worn by the reigning ruler. As a result, the stock of clothes held in the Electoral Tailors' Workshop was no longer continuously added to.

The Rüstkammer in the New Stable Building (Neuer Stall) and in the Zwinger

In 1711, August the Strong decided to have the rooms hitherto occupied by the Electoral Court Tailors' Workshop in the palace converted into residential rooms. Alternative accommodation was therefore required for the garments worn by past Electors. The choice fell on the Rüstkammer (Armoury) which, being responsible for storing and supplying equipment for courtly festivities, already contained an extensive stock of masquerade costumes and textile accessories. The tailor who made garments for court entertainments, and who was the custodian of such items in the Rüstkammer, was now entrusted with the care of the Electoral costumes. They were transferred from the palace to the Rüstkammer in the New Stable Building, and the approximately 250 garments and other objects were assembled in a separate chamber, which was logically called the "Kleider Cammer" (Clothing Chamber). The old Electoral Court Tailors' Workshop presumably ceased to exist. It has not yet been clarified where the workrooms of the court tailors were located after that. Following the death of August the Strong, another ten selected costumes, or 'state dresses', were transferred to the Rüstkammer from the Wardrobe.

By 1821, five successive inventories had been drawn up of the costumes kept in the "Kleider Cammer". Thereafter, a profound change took place, because the Rüstkammer, with its extensive holdings, moved into rooms in the Zwinger that had been vacated after the dissolution of the Kunstkammer in 1832. As part of this process, numerous "defective" items were removed from the collection and sold off. The stock of costumes and textile accessories was also considerably reduced. At the same time, an important collection of European and non-European shoes was incorporated into the stocks in about 1820. This collection had been assembled by Baron Peter Ludwig Heinrich von Block, the former Inspector of the Grünes Gewölbe, who had been suspended and convicted of embezzlement in 1816.

In the new rooms in the Zwinger, the costumes were exhibited for the first time in museum form, being displayed in four glass cabinets. The Rüstkammer, now renamed the

Inventory of the Old Electoral Tailors' Workshop, 1711, Saxon State Archives-Main State Archives Dresden, 10009 (Kunstkammer, Sammlungen, Galerien), No. 256

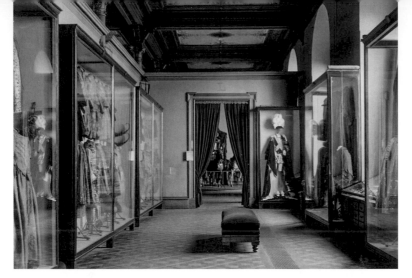

The "Kleiderzimmer" (Clothing Room) in the Historisches Museum Dresden, Johanneum, before 1913

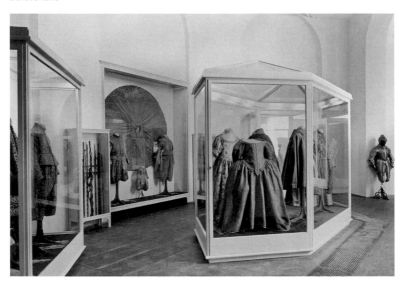

The "Kleiderzimmer" (Clothing Room) in the Historisches Museum Dresden, Johanneum, 1928–1939

Königliches Historisches Museum (Royal Historical Museum), remained in the Dresden Zwinger for about 40 years. The last comprehensive inventory of the Historisches Museum, drawn up in 1838, also included the holdings of garments and shoes presented in the "Kostümzimmer" (Costume Room).

However, structural deficiencies and the small size of the rooms impaired the presentation in the Zwinger and prompted a search for new premises. In 1876–1877, the collection was able to move back into its original building, the former New Stable Building.

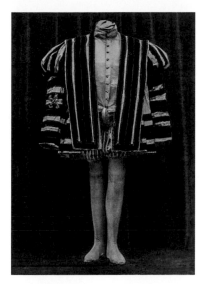

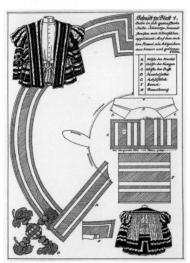

Costume catalogue, before 1940, Rüst-kammer Archive, pattern drawing and coloured photograph of the parade dress of Elector Moritz (→ showcases 1 und 2)

The Königliches Historisches Museum in the Johanneum from 1877 onwards

In the Johanneum, named after King Johann of Saxony, the textile collection was allocated a narrow room in which the objects were exhibited in several large wall display cases and individual showcases. The costumes were presented in two tiers: the lower garments were displayed on figurines with wooden stands, while the upper ones were suspended on hangers. In 1895–1896, extensive conservation measures were carried out on the costumes, but what these actually consisted of can only be guessed at from mentions in the annual reports and from evidence found on the costumes.

In 1914, under the leadership of the new director, Erich Haenel, a comprehensive redesign of the exhibition rooms began. As well as spatial alterations, the exhibition concept was completely reworked and the objects were arranged according to developmental aspects. This work continued, with interruptions, until 1928. The room where the costumes were exhibited did not change in the years 1914–1927, nor is there any mention of major restoration work on the costumes. Photographs of the room give an idea of how densely the display was arranged.

It was not until 1927–1928 that the redesign of the "Kleiderzimmer" (Clothing Room) took place. The costume collection was thoroughly cleaned and repaired and "professionally reinstalled on [...] busts and stands". The presentation was revised by "reconnecting the parts that belonged together according to archival sources, and by verifying and determining the dates" of the individual garments. The costume collection was now spread over several rooms: three interconnected costume halls, the Hall of August the Strong, and the Order Chamber. In the three halls, many costumes were displayed in free-standing showcases, while others were displayed in wall showcases.

During this time of fundamental changes to the museum displays and conservation measures on the costumes, work began on compiling a comprehensive publication about the costumes. Erich

Haenel, director of the Historisches Museum, planned to produce a book containing coloured illustrations of the costumes as well as analytical drawings showing their cut and construction. The completion of this project was prevented by the beginning of the Second World War.

The Second World War, removal for safekeeping, and transportation to the Soviet Union

The presentation did not change again until the beginning of the Second World War. From at least 1938, the threat of war prompted the museums to start thinking about how to protect their holdings and quickly remove them for safekeeping, should the need arise. Like other museums of the Staatliche Kunstsammlungen, the Historisches Museum had to close its doors in 1939. The first measures to protect the holdings were taken: The museum staff packed away the most precious objects from all the collections, including most of the costume collection. The Historisches Museum reopened on 1 January 1940 with a reduced-scale exhibition. The Costume Collection and the Firearms Gallery remained closed.

Under the direction of Erna von Watzdorf, the holdings were finally, and almost completely, removed for safekeeping as of 30 April 1942. In July 1942, Erna von Watzdorf began making special storage

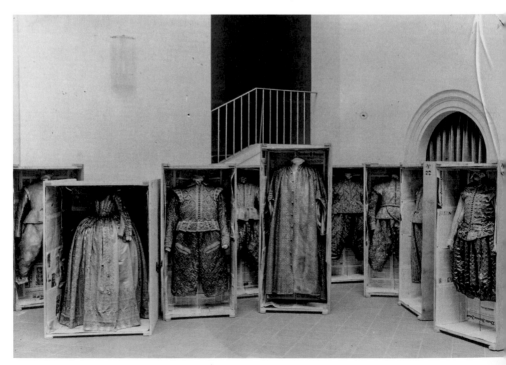

Storage boxes for the costumes in the atrium of the Johanneum, 17 August 1942

boxes for the costumes, which had initially been removed in a hurried and rather makeshift way. In August these objects from the costume collection, some in their newly made boxes, were photographed and then transported to Königstein Fortress, the central storage facility of the Historisches Museum outside the city.

After the end of the war in May 1945, the so-called Trophy Brigades, which specialised in searching for works of art and museum pieces, arrived in the part of Germany liberated by the Red Army. They seized the works of art stored at Königstein Fortress and transported them to the Soviet Union. The boxes belonging to the Historisches Museum were removed between 9 May 1945 and 18 April 1946, at which time the museum practically ceased to exist. Only a few items remained, such as carriages, flags, several paintings, parts of Ottoman tents, and the inventories of the collection. During the air raids on Dresden in February 1945, the Johanneum was hit by incendiary bombs and burnt out. The building, which was rebuilt in 1950, subsequently housed the Transport Museum.

The Historisches Museum from 1958 onwards

On 20 March 1955, the Central Committee of the Communist Party of the Soviet Union decided to return masterpieces of art to the GDR, initially mainly those from Dresden's Gemäldegalerie Alte Meister. In 1958, this was followed by a further 1.5 million or so of the museum objects that had been taken to the Soviet Union; they were handed over to museum staff from Berlin, Dresden, Leipzig, Potsdam, and Weimar.

The costume collection of the Historisches Museum was held at the Hermitage in Leningrad and was returned to Dresden via Berlin. For this purpose, the costumes were packed once again into the boxes that had been made for them in Dresden in 1942, and they arrived back in October 1958. Despite some lamentable losses, the collection remained largely intact.

In addition to unpacking and identifying the objects, the museum staff quickly organised a special exhibition to show the returned treasures to the public. The show entitled "Der Menschheit bewahrt" (Preserved for Humanity) opened on 3 November 1958 in the East Hall of the Semper Building at the Zwinger. Five costumes from the Historisches Museum were displayed with objects from other collections. The following year, on 8 May 1959, a second exhibition of the same name was opened, this time presenting art treasures from six museums. The 104 objects from the Historisches Museum on view there included twelve costumes dating from the sixteenth to eighteenth centuries, as well as 14 pairs of shoes.

In parallel with this show, the far larger permanent exhibition of the Historisches Museum, incorporating around 800 objects, was being installed in the East Hall of the Semper Building at the Zwinger. It opened on 10 October 1959. This permanent exhibition, which focused primarily on the museum's collection of ceremonial arms and armour, remained in place until the start of extensive reconstruction and restoration work on the Semper Building in 1989–1992. After its reopening in 1992, the museum was renamed "Rüstkammer" (Armoury) and about 1,300 items were exhibited in the East Hall.

After 1959, most of the costumes, on the other hand, remained in the storerooms and were only occasionally shown in special exhibitions, as part of the series entitled "Kunstwerk des Monats" (Artwork of the Month), or in publications.

The Electoral Wardrobe in the Residenzschloss since 2017

Work on reconstructing the Dresden Residenzschloss began in 1986, and in 1994 it was determined that the palace would in future be entirely devoted to museum use. A cabinet decision in 1997 confirmed that the Rüstkammer was to have its permanent home there. The "Türckische Cammer" (Turkish Chamber), which was installed and opened in 2010, was the first section of the Rüstkammer to move into the palace. In 2017, the "Electoral Wardrobe" in the north wing of the Residenzschloss opened as the first permanent exhibition of Renaissance and early Baroque costumes for more than 80 years. The sumptuous princely garments are presented individually in custom-made showcases. They are displayed on aesthetically pleasing figurines that meet the conservational requirements of these fragile textiles, and they are supplemented by precious ceremonial weapons, magnificent hunting accessories, saddles, sword hangers, gloves, and portraits.

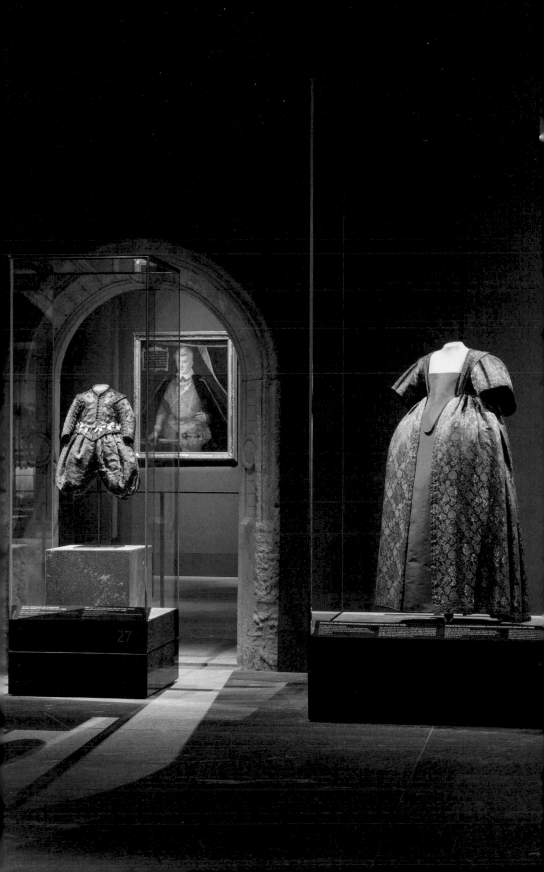

Room 1

Parade dresses and weapons of Electors Moritz (1521–1553), August (1526–1586), Christian I (1560–1591), Christian II (1583–1611) and Johann Georg I (1585–1656) of Saxony

The Dresden Rüstkammer is the only place where original examples of sixteenth-century European princely fashion, influenced by Spanish and Italian taste, have survived as complete garment ensembles. The original items of clothing that belonged to Electors Moritz and August of Saxony illustrate fashion phenomena of that period that can otherwise only be seen on portraits or are found as funerary objects in princely tombs: various forms of men's coats, short trunk hose with codpiece, decorative slashes, and knitted silk stockings. The preservation of princely clothing after its owner's death was started by Elector August in 1553, initially to honour his deceased brother Moritz, the first Elector of Saxony from the Albertine branch of the House of Wettin, and this practice was continued by subsequent generations. Both the parade garments and the ceremonial weapons – with their abundance of silk, gold, silver, gemstones, and pearls – were part of the state treasury. As the personal clothing of rulers worn on important occasions, they also functioned as memorial objects glorifying the dynasty. JCvB

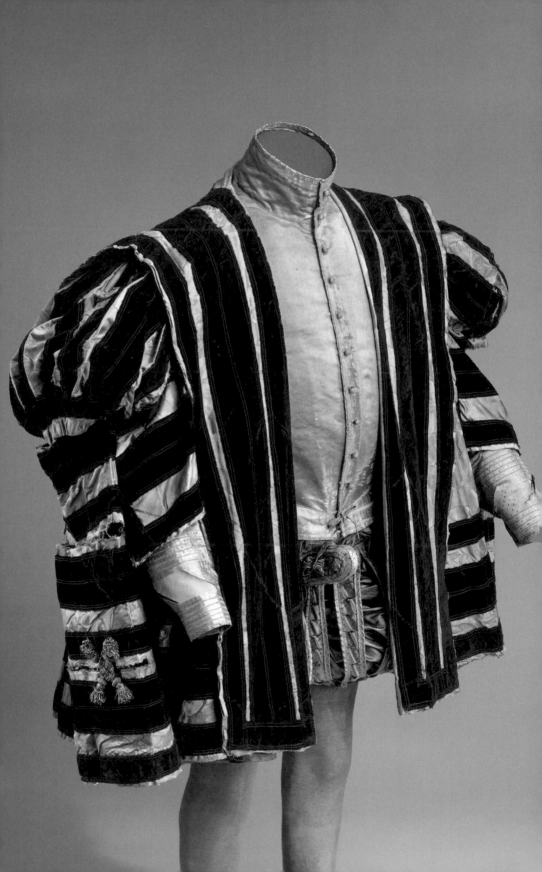

Parade dress of Elector Moritz of Saxony

Coat
Doublet, trunk hose, and stockings in showcase 2
c. 1545–1550, outer fabrics: Italian;
tailoring: Dresden, Ducal or Electoral Tailors' Workshop (?)
Yellow silk damask, black silk velvet, silver and gold trimmings
Circumference: 628 cm; sleeves: length 91 cm
Restored by the Abegg-Stiftung in Riggisberg, Switzerland as a donation
Rüstkammer, inv. no. i. 0001

This bright yellow parade dress with black velvet stripes on the voluminous coat is in keeping with Spanish and Italian princely fashion around the middle of the sixteenth century. It is among the items of clothing left by Elector Moritz of Saxony. Alongside other garments worn by Moritz, it is recorded in the clothing inventory drawn up in 1553. There, the different parts of this parade dress are listed separately under the categories of coats, doublets, and trunk hose. They are not identified as forming an ensemble until the inventories compiled from 1711 onwards. Their association with Moritz is based on personal references to him and on the fact that the garments conform to the fashion of that era. It has been substantiated more recently through scientific investigation of the dyes used and the sewing techniques employed. The yellow silk of the yarns used in the fabrics was very probably dyed in the same silk manufactory. The same yellow sewing thread was used on all parts of the garment.

The parade dress was specifically tailored for Moritz. Especially the tight-fitting doublet, the hip-hugging short trunk hose, and the skin-tight leather stockings convey a vivid impression of the stature and virility of the Saxon Elector, who was widely acclaimed for his boldness. The short coat and the choice of bright colours, which here are to be understood as an exquisite fashion sensation and not as a reference to the colours of the Saxon ruling house, show their owner to have been acutely fashion-conscious and keen to display his physical prowess.

The coat was originally longer. Moritz had it specially shortened. All the edges are unhemmed, as was fashionable at the time. The extra-long hanging sleeves are purely decorative in function. The arms were passed through armholes covered with a decorative flap. The broad upper arm puffs gave the impression of broad shoulders.

The coat, the principal element in the parade dress, is made of silk damask with a pomegranate and pine cone pattern, which probably derives from the Florentine Peri and Perotti silk weaving workshops, who supplied the Medici, the Dukes of Florence. The design incorporates the Medici diamond ring with a crown and three pears. No less than 14 metres of the luxurious fabric, which has a weave width of 55 centimetres, were used in producing the coat with its enormous circumference of 6.28 metres. The addition of black velvet stripes with appliqué silver lacing along all the edges increased the value and magnificence of the coat. The slashes in the sleeves were held together by a total of 22 large gold passementerie knots, only one of which survives. During the restoration at the Abegg-Stiftung from 2002

Room 1

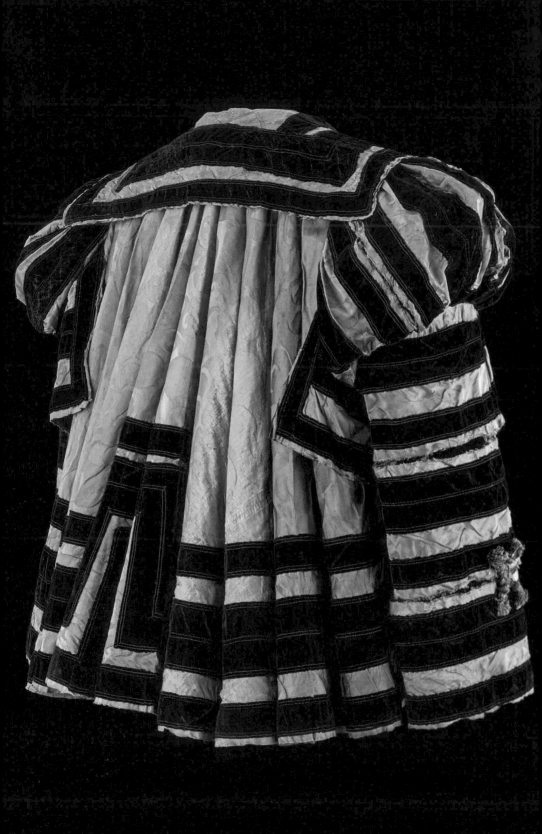

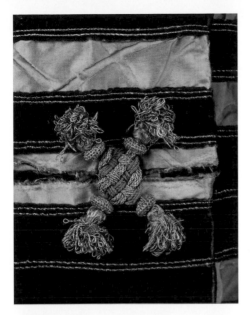

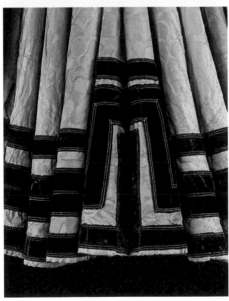

to 2008, old restorations based on misunderstandings, such as sewn-up slits and folded hems, were carefully removed from the coat on the basis of the findings indicating its original state. The splendour of the folds is presented to great effect with the aid of a support structure.

When looking at portraits of Moritz's great contemporaries, first and foremost Emperor Charles V, King Ferdinand I, Henry VIII of England, Philip II of Spain, Francis I and Henry II of France, Cosimo I de' Medici Duke of Florence and, last but not least, Elector Johann Friedrich I, the Magnanimous, of Saxony, and Landgrave Philip of Hesse, it is clearly evident that this coat was at the cutting-edge of princely fashion and that it is to be seen in the context of European dynastic and political inter-connections. JCvB

Room 1

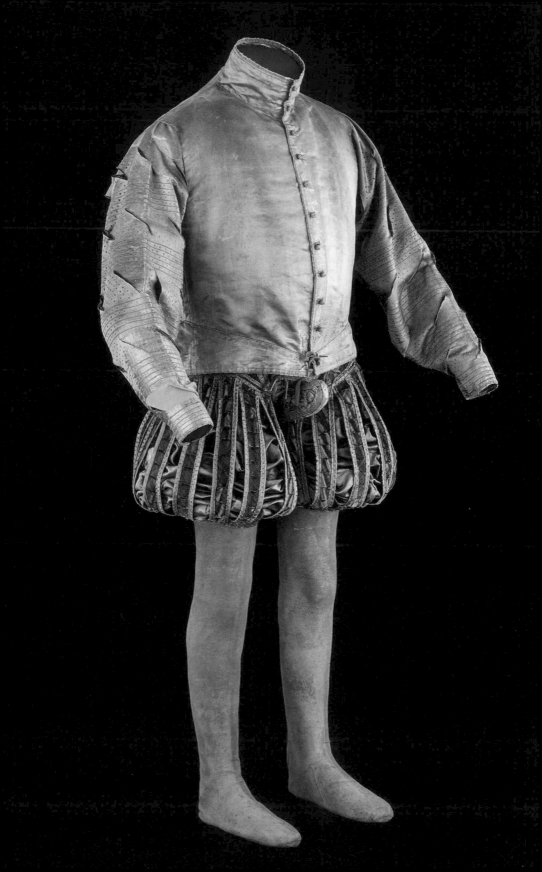

Parade dress of Elector Moritz of Saxony

Doublet, trunk hose, and stockings
Coat in showcase 1
c. 1545–1550, outer fabrics: Italian;
tailoring: Dresden, Ducal or Electoral Tailors' Workshop (?)
Yellow silk satin and silk velvet; hacking and slashing, decorative seams;
trunk hose wadding: yellow silk satin; stockings: yellow chamois leather
Restored by the Abegg-Stiftung in Riggisberg, Switzerland as a donation
Rüstkammer, inv. no. i. 0001

This long-sleeved waisted doublet, which features a high standing collar, is fastened at the front with small silk passementerie buttons, and has short laps, is somewhat rounded and pointed in the abdominal area, following the Spanish fashion. The outer fabric consists of yellow silk satin. The loose-fitting sleeves have a geometric pattern of holes and stripes and large diagonal decorative slits. The "Spanish" short, puffy trunk hose consist of three layers. The outer layer is made of yellow silk velvet and yellow silk satin with a slit pattern, divided into panes. Inside this is a generous layer of wadding made of yellow silk satin, decoratively crumpled and fixed in place. The innermost layer consists of the upper section of the leather stockings, which cover the buttocks. When dressing, the doublet and trunk hose would have been tied together with yellow silk ribbons to ensure a perfect fit. At the front of the trunk hose is an elaborately decorated codpiece. JCvB

Room 1

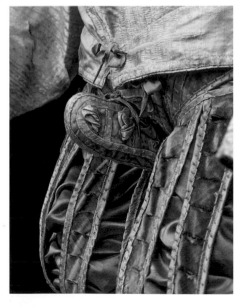
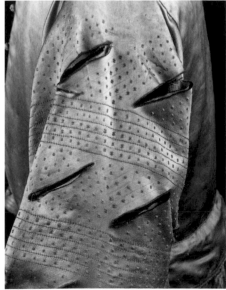

AFTER TITIAN OR ANTHONIS MOR
Elector Moritz of Saxony

c. 1550
Oil on canvas; 126 × 89 cm
Inscribed: "MAURITIUS · DUX · SAX · ELC ·"
Rüstkammer, inv. no. H 0168

Elector Moritz of Saxony is depicted as a victorious general with a sash in the imperial colour red, and a commander's baton. The blued armour is decorated with bands of etched and gilded ornamentation. On the table or balustrade draped with red silk velvet is the matching helmet with a plume of red ostrich feathers.

This portrait follows a portrait type that was first used by Titian in 1547/48 for a portrait of Emperor Charles V, now lost, in recognition of his victory in the Battle of Mühlberg. It was a half-length portrait depicting the Emperor as a military commander wearing armour, holding the commander's baton, and wearing the Order of the Golden Fleece. The protagonists on the imperial side in the Battle of Mühlberg and the campaigns against the Ottomans, including Moritz, repeatedly had their portraits painted in the manner of this image of the Emperor. CN/JCvB

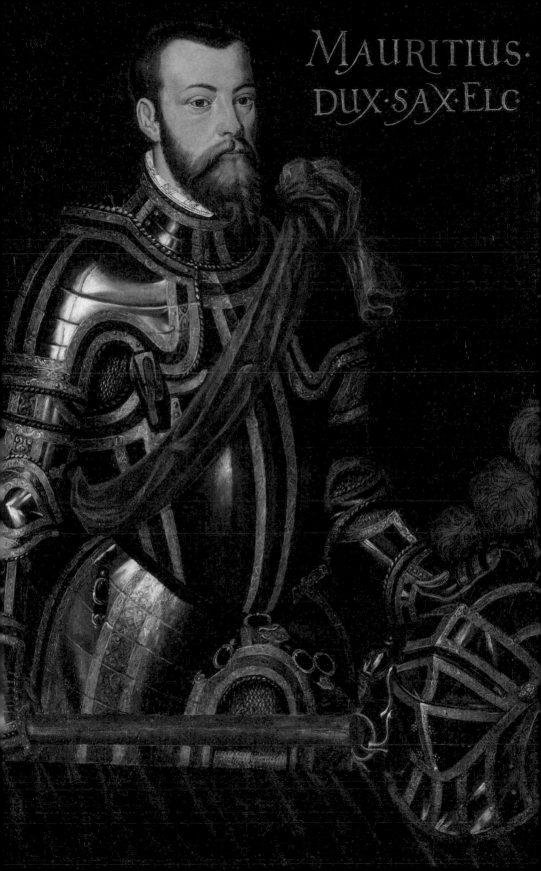

MAURITIUS·
DUX·SAX·ELC

Gentleman's shoe, so-called cow-mouth shoe

South German, c. 1530–1540
Black cowhide, chased and embossed
Length: 27 cm
Rüstkammer, inv. no. i. 0102

Described in the catalogue of Peter Ludwig Heinrich von Block's shoe collection as the "shoe of Emperor Charles V", this cow-mouth shoe – in the particularly luxurious 'horned' version – does indeed fulfil all the requirements for such an attribution. The flat shoe is wide at the front and sides and has a raised heel counter over a low but pronounced heel. The broad toe cap – thought to resemble a cow's mouth – protrudes sideways like horns. It is decorated with narrow pleats, which correspond to the fashion for pleats and slashes in the clothing of the 1520s to 1540s. The outer sole is stabilised by a slightly elevated leather frame. The inner sole, which shows signs of use, has a diamond pattern embossed across the surface. JCvB

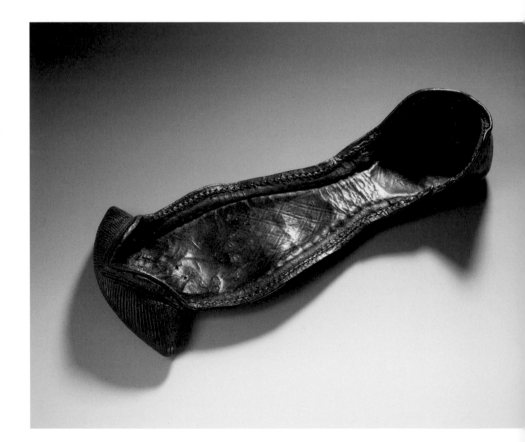

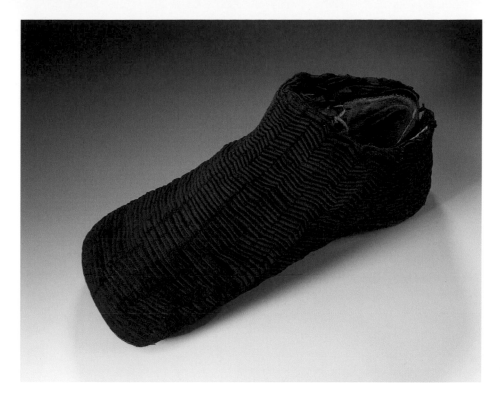

Showcase 4

Riding shoe

German, c. 1540–1550
Leather, covered with black velvet, folded; lacing at the heel;
inner shoe: chamois leather
Length: 28.5 cm
Rüstkammer, inv. no. i. 0105

This flat shoe with a wide toe cap is a variant of the cow-mouth shoe. It encloses the entire foot. The pleated black silk velvet laid closely together across the whole surface follow the fashion for pleats popular in the first half of the sixteenth century. The decision to lay the velvet in bands makes it possible to harmoniously adapt the pleating to the curves of the shoe. The shoe is designed as a riding shoe, presumably intended for use in a tournament. The overshoe with the pleated velvet encloses a leather inner shoe with side lacing. The two are sewn together only halfway so that a spur can be attached by straps to the inner shoe. There are six metal hooks at the heel for fastening the overshoe with a lace. JCvB

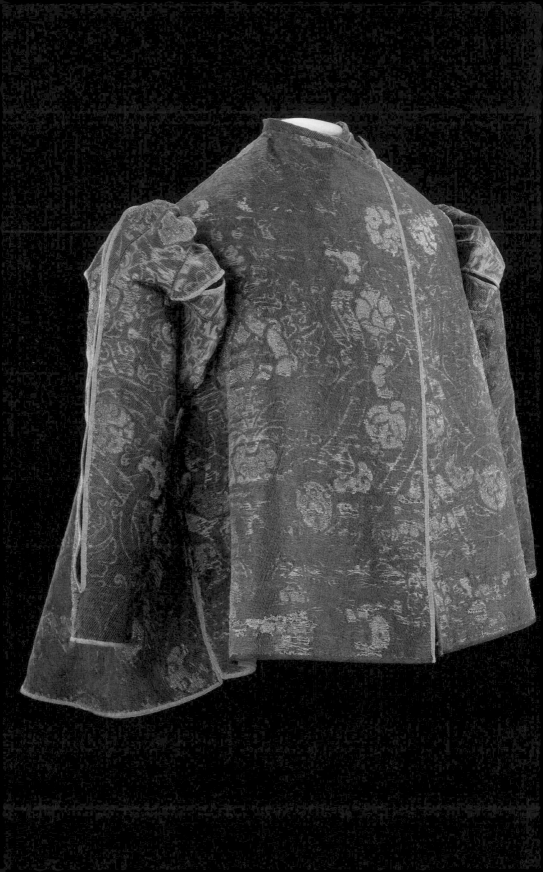

Bridegroom's costume of Duke August of Saxony worn at his wedding to Anna of Denmark in Torgau in 1548

Coat and pair of stockings
Doublet and trunk hose in showcase 6
1548, outer fabric: Italian;
tailoring: Dresden, Electoral Tailors' Workshop (?)
Coat: lampas, white and brown silk, silver wire, lancé, gold threads, brocaded,
weft-loop weave; gold edging; stockings: white silk yarn, knitted
Coat: length 71–84 cm; circumference: 351 cm; Stockings: length 57 cm
Rüstkammer, inv. no. i. 0004

This parade garment in Spanish-Italian style was worn by Duke August of Saxony for his wedding to Anna of Denmark in Torgau in 1548. The sumptuous ensemble listed as a "bridegroom's dress" comprises a coat, doublet, and an overknee length trunk hose made of gold-brocaded silver fabric with a pomegranate pattern, and knitted white silk stockings. It is undoubtedly the most precious of the sixteenth-century garments held in the Dresden Rüstkammer.

The fashionable hip-length coat, known as an "umbnehm rock" ('wrapping coat'), would only have been draped over the shoulders. The decorative puffed and slashed sleeves would have been embellished with ornamental gold pins. Originally, the coat had a lining of sable fur, which at that time was one of the most luxurious and costly furs. Anna had it taken out for use in another garment.

The original design of the damaged standing collar can be deduced from portraits of princes from the imperial family. The outer fabric consists of a white-silver lampas with a golden pomegranate pattern, the overall colour value of which can be assessed as white. The overall white appearance of August's bridegroom's dress was achieved by the dense network of fine lancé silver wire, which resulted in the silk fabric being designated a "silbern stück" (silver piece). The pattern consists of an arrangement of pointed ovals, each of which contains a large stylised golden pomegranate as the central motif. This is framed by scrolling foliage and strapwork in white, as well as golden floral motifs. The pomegranates and flowers are woven in gold burl brocade in two-level relief, from which the designation "gülden stück" (golden piece) derives. Silk fabrics with a stepped bouclé effect in gold and silver were the pride of Florentine silk workshops in their day. Their preciousness was compared to that of jewels.

The extraordinary quality of the fabric was severely marred by the effects of exposure to light and the air. Following its painstaking restoration, the former splendour of the ensemble, and its designated purpose as a wedding garment, can now again be appreciated.

The hand-knitted white silk stockings with decorative edging were synonymous with supreme elegance and utmost luxury. In the second quarter of the sixteenth century, under the influence of Spanish-Burgundian court ceremonial, the transition from sewn fabric stockings to more elegant elastic, tight-fitting knitted silk stockings took place in European princely fashion. Such stockings were still very

Room 1

rare and expensive in 1548. August's stockings are probably the earliest original such stockings belonging to a European secular ruler to have been preserved in a museum. Comparable originals held in other museums have been salvaged from the tombs of their respective princely owners.

The luxurious bridegroom's dress made for August was altogether oriented towards the imperial house and testifies to the special ambition that Moritz associated with the wedding. The marriage not only established a dynastic connection between the Electorate of Saxony and a royal house, but also helped strengthen the Protestant side in the Holy Roman Empire. Although the wedding did not take place at the Danish royal court, as had been hoped, Moritz triumphantly fulfilled his promise to his brother that in Torgau he would host a magnificent wedding for him, such as had never been seen before for any prince of Saxony. JCvB

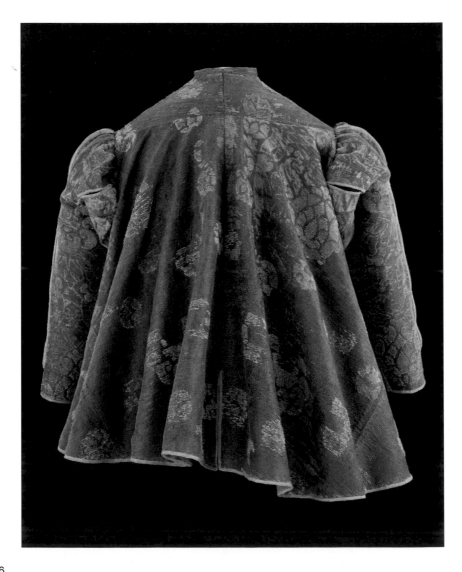

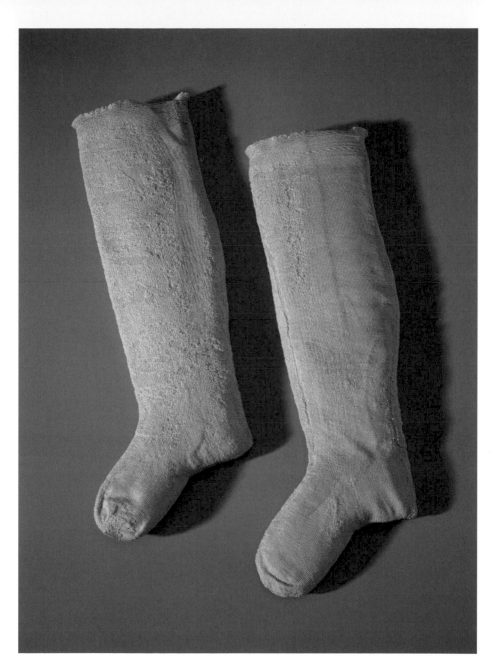

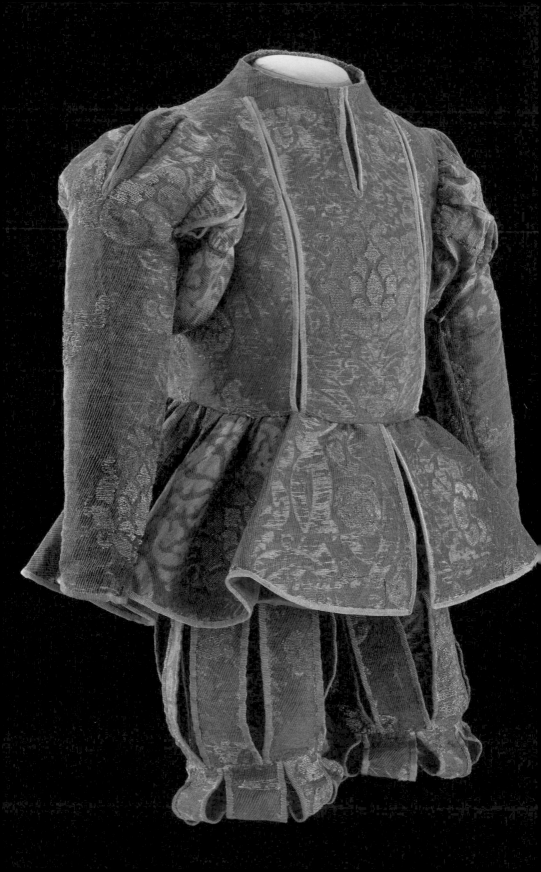

Bridegroom's costume of Duke August of Saxony
worn at his wedding to Anna of Denmark in Torgau in 1548

Doublet and trunk hose
Coat and stockings in showcase 5
1548, outer fabric: Italian;
tailoring: Dresden, Electoral Tailors' Workshop (?)
Lampas, white and brown silk, silver wire, lance, gold threads,
brocaded, weft-loop weave; gold lace; Inner hose: goatskin
Rüstkammer, inv. no. i. 0004

The bridegroom's costume made of silver fabric decorated with golden pomegranates, a symbol of fertility, was selected specifically for the wedding. With the dominant colour being white – silver being equivalent to white – it conformed to the trend of wearing white at weddings, a fashion that had only recently reached Saxony.

The waisted doublet with longitudinal slashes has hip-length laps and long sleeves puffed at the top. Its sumptuous décor and style are such that this striking garment could be worn in public without the need for a coat. The elegant contours are accentuated by gold trim on the edges and seams. Below the left sleeve is a flap with small holes for aglets to pass through. The skirted, slashed thigh-length trunk hose have a codpiece, in keeping with the fashion of the time.

With its exquisite fabric quality and stylish design, this costume represented the ultimate in contemporary princely attire, as is evident from portraits of Italian princes and members of the imperial house. JCvB

Room 1

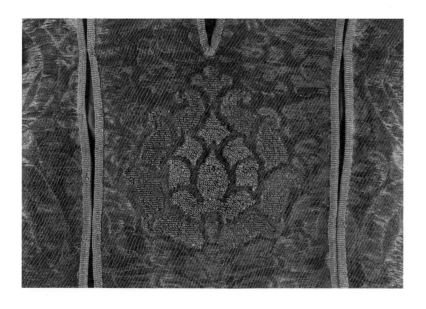

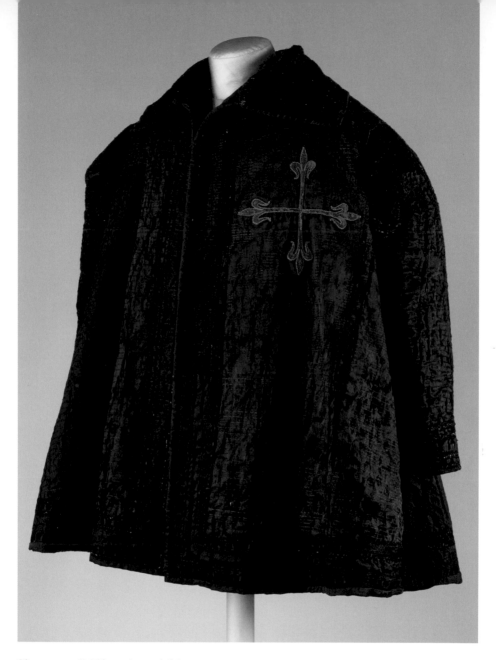

Showcase 7 / Changing exhibit

Coat taken as booty by Elector Moritz of Saxony from the campaign against Emperor Charles V in 1552

Man's coat
Spanish (?), c. 1545–1550
Black silk velvet and silk satin; cross of the Order: red wool and
silk appliqués; lining: black silk velvet pelt, pile length 0.5 cm
Circumference: 470 cm
Rüstkammer, inv. no. i. 0003

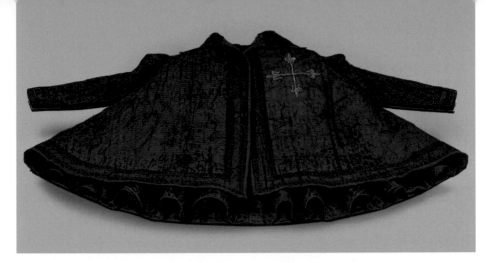

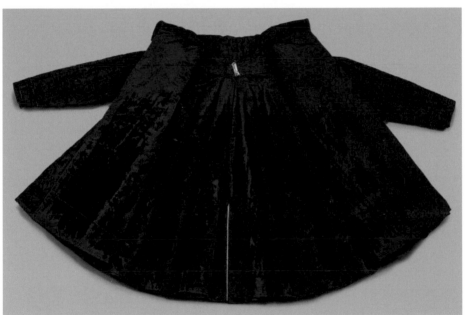

This elegant coat bearing the fleur-de-lis cross of the Spanish Order of Calatrava was looted from the baggage train of Emperor Charles V as he fled from the Holy Roman Empire. In a military campaign, Moritz had pursued the Catholic Emperor as far as Innsbruck, where he was forced to flee.

In 1552, following the successful Princes' War, the Treaty of Passau was negotiated with King Ferdinand I, granting recognition to the Protestants in the Empire. The Emperor never again set foot on German territory. Moritz brought the "Innsbruck Booty" to Dresden as a victory trophy.

This knee-length black coat with a hem circumference of 470 cm has slashed puffed sleeves and two "spanish satin trimmings" as borders. It could be laid over the shoulder or worn. This coat is sensational on account of its lining made of a luxurious silk velvet faux fur. JCvB

Parade dress of Elector August of Saxony

Jerkin, doublet, trunk hose
Between 1567 and 1575, fabrics: Italian;
tailoring: Dresden, Electoral Tailors' Workshop, Hans Frank
Yellow silk satin, black silk filet lace; trunk hose wadding: lampas,
black silk, gold wire, lancé; lining fabrics: yellow silk taffeta, fustian;
inner hose: buckskin leather; ribbons with aglets (not original)
Restored by the Abegg-Stiftung in Riggisberg, Switzerland as a donation
Rüstkammer, inv. no. i. 0005

This parade dress of yellow silk satin covered all over with black silk lace was first recorded in the 1575 inventory of the Electoral Tailors' Workshop and belonged to Elector August of Saxony. It consists of a jerkin, doublet, and trunk hose. Originally, the magnificent ensemble was complemented by 14 crystal buttons in gold settings on the front of the jerkin and on the cuffs of the doublet, as well as numerous small gold rosettes. The individual components and materials of this set of garments are only fully described in the inventory of 1584.

The close-fitting jerkin with quarter sleeves, shoulder pads, high standing collar, slightly protruding pointed stomach, and hip-length flared laps, is completely overlaid with large-patterned black silk filet lace. The tightly waisted Spanish-style doublet has a tapered waist seam, an intimated peascod belly, and short laps. It thus shows parallels to the doublet of Elector Moritz (showcase 2). The doublet was worn under the jerkin, which is why only the visible sleeve sections are decorated

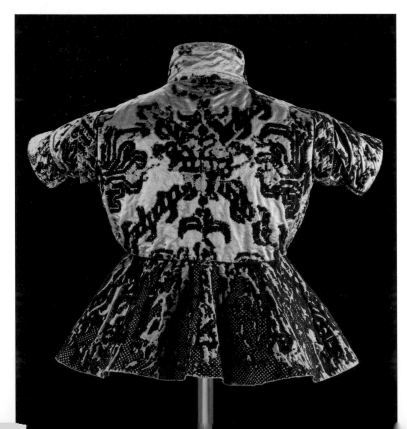

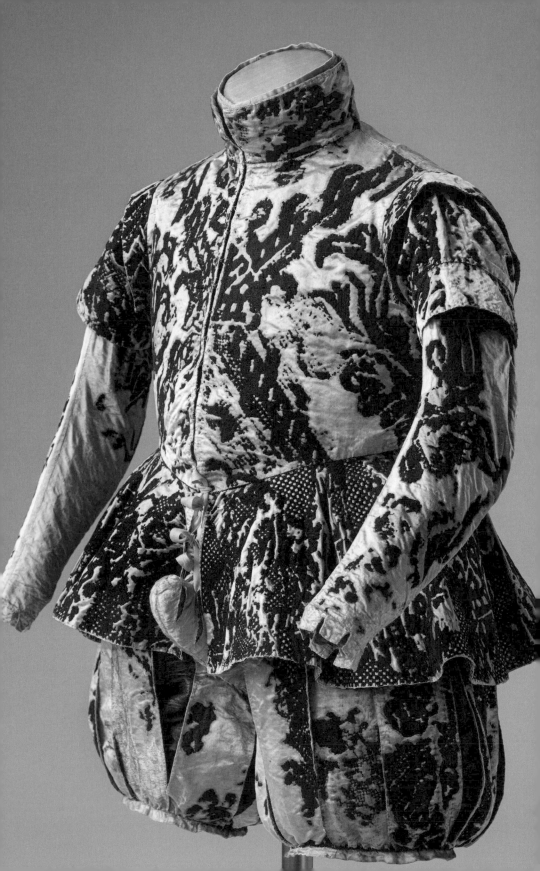

with black lace, like the jerkin. Two pieces of yellow silk satin have been inserted into the side seams of the doublet to fit a larger body.

The trunk hose are constructed of three layers. The outer hose of yellow silk satin covered with appliqué black silk lace comprise the waistband, seven longitudinal stripes with a width of about ten centimetres for each leg, a round/oval seat section designed for riding, and a triangular fly with a codpiece. The inner hose are made of natural-coloured soft goatskin. Between it and the outer hose is a layer of luxurious black and gold lampas that bulges out attractively through the slits.

The sensational feature of this magnificent parade dress was the black silk lace covering much of its area. During the meticulous restoration of the dress at the Abegg-Stiftung from 2015 to 2019, the surviving parts of the lace, which had been covered over by securing stitches during an earlier restoration effort, were largely uncovered again. The lace is key to appreciating the high value of these garments. In the inventory of 1584, the dress was listed along with the black coats "von gemosirten Sammet" (made of patterned velvet).

Hence, the black silk lace and not the yellow silk satin was considered the main feature and deemed to be on a par with patterned black silk velvet. The lace is not bobbin lace or a knitted net, as repeatedly stated in older records, but filet lace using black silk yarn. A large diamond pattern featuring bars, ribbons, palmette foliage, and pomegranate motifs is worked into a silk square mesh using linen darning stitch and interlacing stitch, modelled on a popular weaving pattern. On August's jerkin it is arranged in such a way that the large bars of the lozenges on the chest and back each form a diagonal cross at the centre, thus evoking associations with the cross of St Andrew or cross of Burgundy. The dress, which seems quite improvised in its tailoring, may have been used by August as a costume for a tournament.

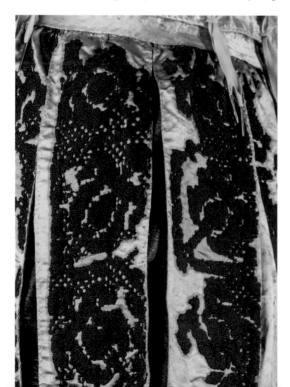

In this case, the colours yellow and black would be considered heraldic colours from the ducal Saxon coat of arms. JCvB

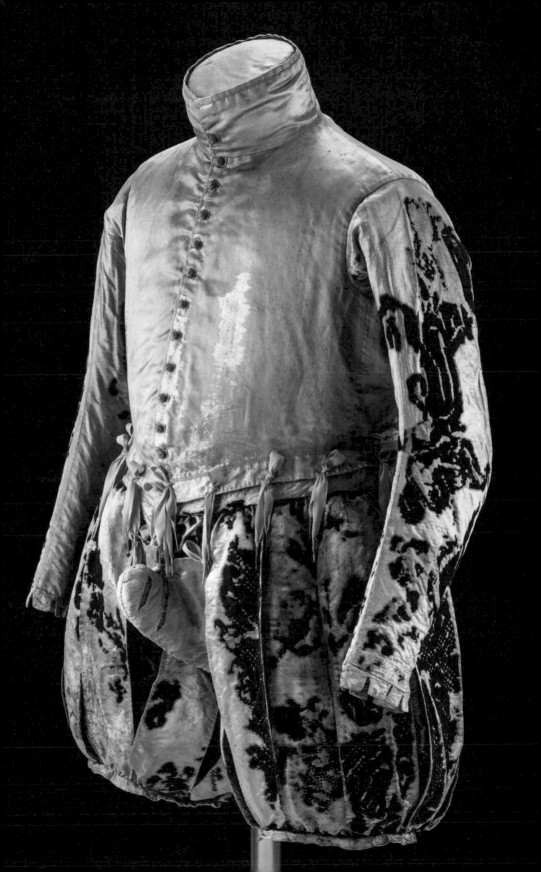

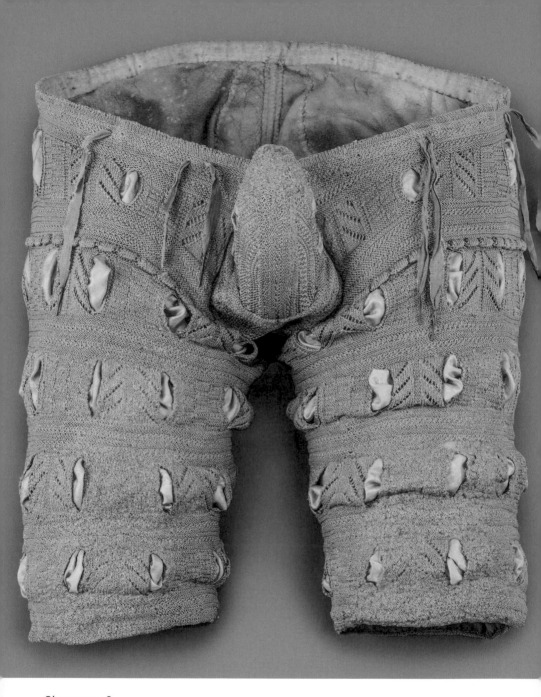

Showcase 8

Knitted silk trunk hose of Duke August of Saxony

Mid-16th century, before 1555
Yellow silk yarn, knitted: herringbone, chessboard, and striped
patterns; 5 yellow silk ribbons with aglets (original 17);
trunk hose wadding: yellow taffeta; inner hose: goatskin
Rüstkammer, inv. no. i. 0057

The tight-fitting, short yellow trunk hose with decorative slashes and a codpiece were listed among other knitted silk garments in the inventory of August's clothing drawn up at the end of 1555. It was described as "a pair of yellow knitted Spanish trunk hose". Elector Moritz had also owned knitted silk shirts, hose, and stockings. As examples of European silk knitwear around the middle of the sixteenth century, these yellow knitted trunk hose and the white stockings accompanying August's bridegroom's dress (showcase 5) are unique in having been continuously preserved as part of a collection. With their close-fitting shape, the short legs, the prominent codpiece, and the diagonal decorative braids in the groin area, which make the legs appear longer and the hips narrower, these trunk hose combine utmost princely elegance with erotic appeal. JCvB

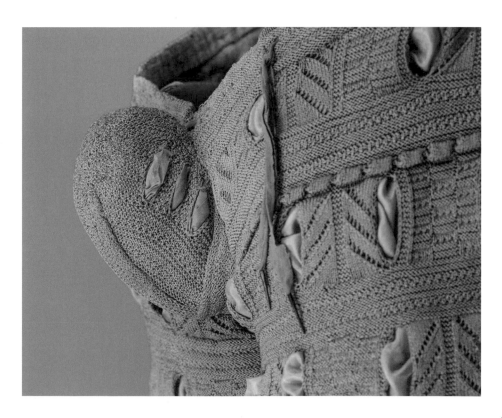

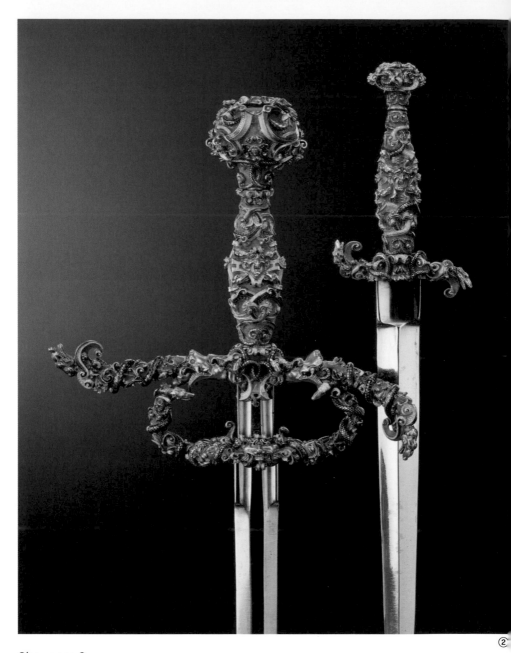

②

Showcase 9

Two golden rapier-and-dagger garnitures

Pere Juan Poch [Pockh], Vienna, 1561–1562 ① / 1556 (?) ②
Iron, gold, enamel, wood, red silk velvet (originally black)
Rüstkammer, inv. nos. VI 0416; p. 0218 ① / VI 0414; p. 0215 ②

These two exquisite garnitures of parade weapons were given to Elector August
in 1556 by Archduke Ferdinand ② and in 1562 by Maximilian II to mark his election
as King of Germany (King of the Romans) in Frankfurt am Main ①. They are among

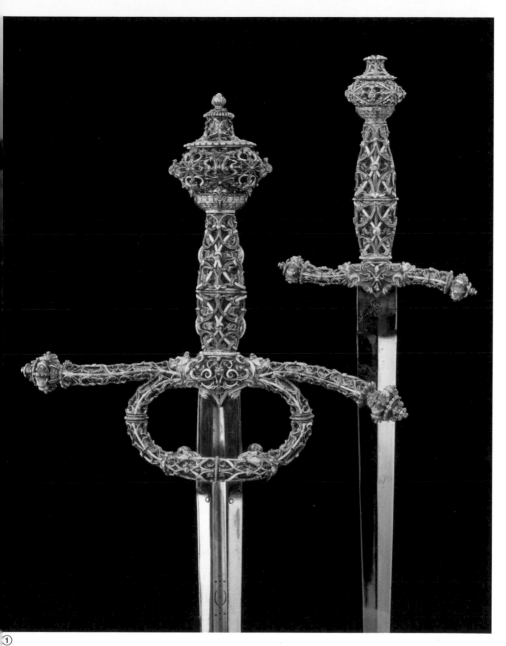

① the four golden, colour-enamelled rapier-and-dagger garnitures with relief décor featuring fantastical plants and animals, crafted by the Spanish goldsmith Pere Juan Poch, which came to Dresden as gifts from the imperial family. August had himself depicted with the garniture given by Ferdinand in a full-length portrait by Hans Krell held in the Dresden Rüstkammer. In that portrait, painted in 1561, August wears a parade dress decorated with gold enamelled "flying hearts" and precious stones. JCvB

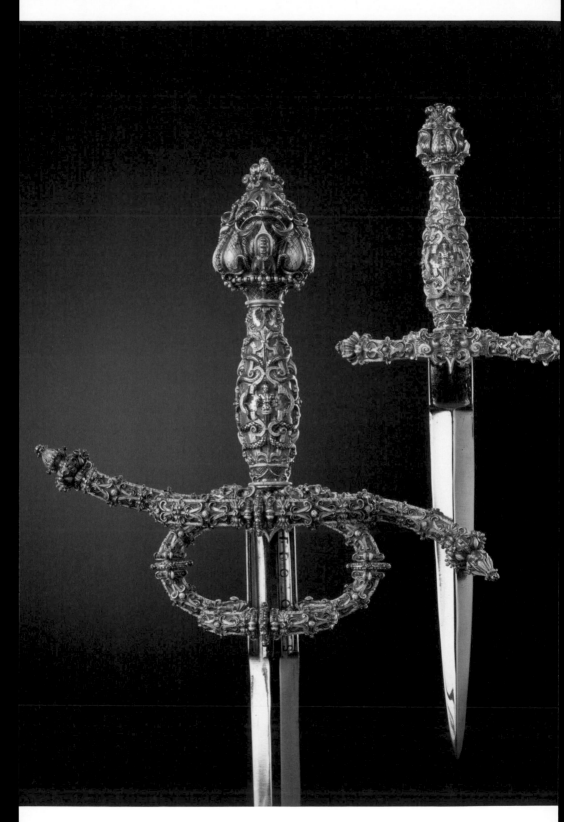

Golden rapier-and-dagger garniture

Pere Juan Poch [Pockh], Vienna, 1575
Iron, gold, enamel, wood, red silk velvet (originally black)
Rüstkammer, inv. nos. VI 0413; p. 0213

This rapier-and-dagger garniture was a gift from Emperor Maximilian II to Elector August of Saxony given during his visit to Dresden in 1575. The elegant hilt is covered with virtuoso goldsmith's work, featuring scrolls and strapwork embellished with shells, ornamental borders, masks, and caryatids, executed in relief. This, the most beautiful and splendid of the four golden garnitures made by Poch that came to Dresden, appears in the imperial court accounts, in which the goldsmith Pere Juan Poch is mentioned by name. The garniture cost 1,611 gulden and 48 kreuzer. The maker's fee of 1,000 gulden far exceeded the value of the gold, cited as 399 crowns, which underlines Poch's exceptional status as an artist in his day. JCvB

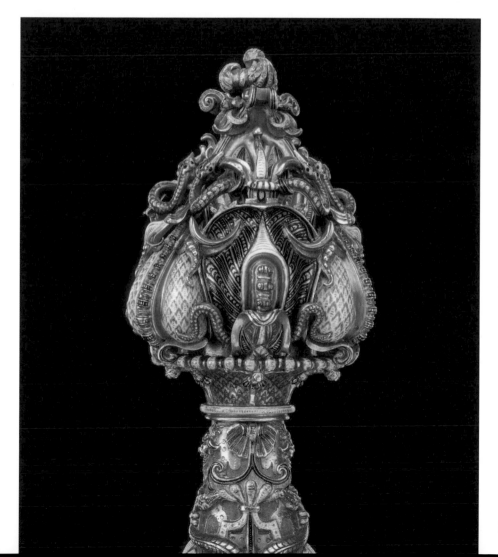

Room 1

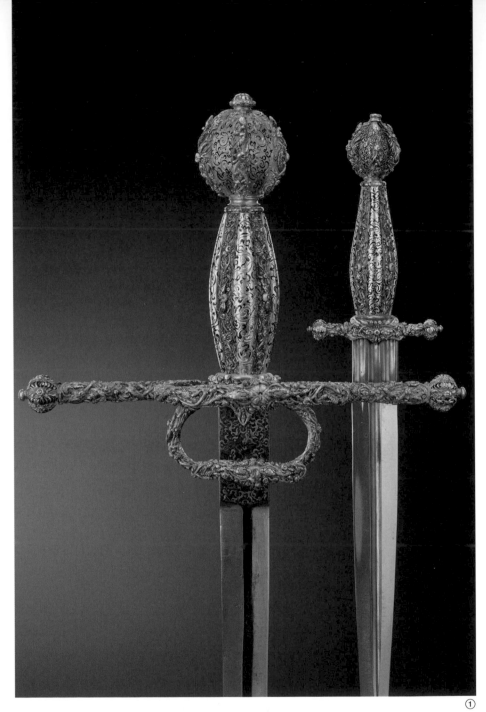

①

Showcase 11

Two golden rapier-and-dagger garnitures

Munich (?), c. 1560–1567 ①
Pere Juan Poch [Pockh], Vienna, 1575 ②
Iron, gold, enamel, wood, red silk velvet (originally black)
Rüstkammer, inv. nos. VI 0415; p. 0216 ① / VI 0412; p. 0214 ②

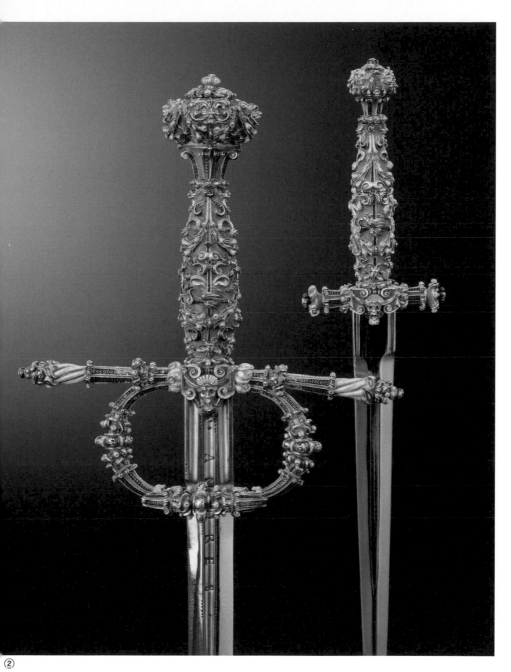

② During his visit to Dresden in 1575, Emperor Maximilian II presented a rapier-and-dagger garniture by Pere Juan Poch not only to Elector August (showcase 10), but also to the 15-year-old Electoral Prince Christian (I) of Saxony ②. The older garniture ①, which is less Mannerist in style, was a gift given to August by Duke Albrecht V of Bavaria. Despite their confessional differences, the two princes enjoyed a lifelong friendship. JCvB

Dagger depicting Fortuna

Christoph Weiditz, Augsburg, mid-16th century
Iron, ivory, silver, gilt, wood, brown velvet (originally black leather),
horn, brass rivets
Rüstkammer, inv. no. p. 0203

This dagger, crafted by Christoph Weiditz in the middle of the sixteenth century,
is a masterpiece of small-scale sculpture. A herm in gilded silver and ivory forms the
handle. The female figure follows the classical ideal of beauty. The silver-gilt locket
of the scabbard features Fortuna gliding over the water on a dolphin, and a smiling
girl holding a rose branch and uncovering a scroll bearing the device "GELICK
VND FREYD" (luck and joy) on the chape. The dagger is the only signed work by
this artist, who worked as a sculptor, medallist, and goldsmith. The dagger may have
been purchased by Elector Moritz during the Imperial Diet in Augsburg in 1548 with
a view to the forthcoming wedding of his brother August. JCvB

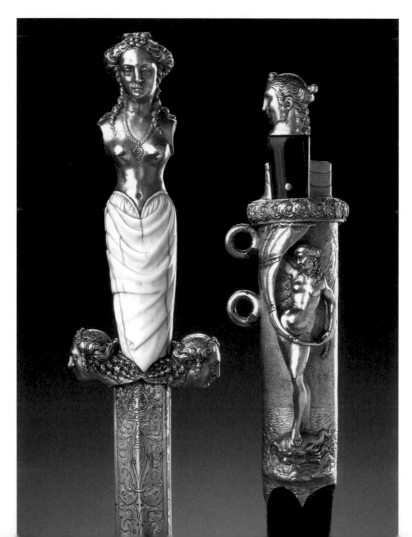

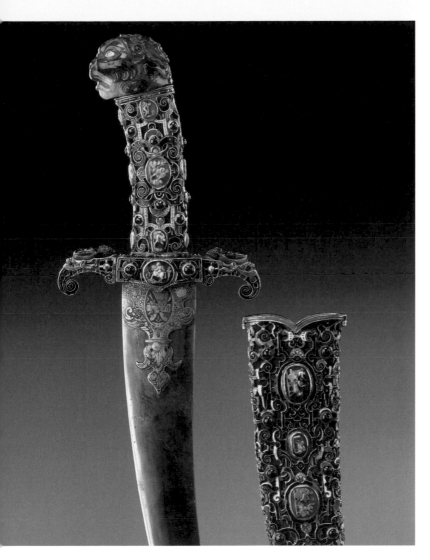

Showcase 13

Dagger with cameos

Presumably Milan, c. 1585
Iron, gold, enamel, onyx, rubies, garnets, cameos, wood
Rüstkammer, inv. no. p. 0221

This dagger with scrollwork in solid gold and enamel is mounted with 2 rubies,
56 garnets, and 29 (out of the original 30) cameos depicting classical figures,
including Hercules, Marcus Curtius, Orpheus, Leda with the swan, and Bacchus.
The pommel, which is made of carved onyx, is shaped as a dragon's head with
rubies as eyes and the head of Medusa on the back. This is a reference to Perseus,
a hero of classical mythology, as are also the half-length female figures on the
quillons. This magnificent weapon was a gift given to Christian I of Saxony by Duke
Carlo Emanuele of Savoy. JCvB

Doublet and hose belonging to the Saxon Electoral Regalia

c. 1584–1590, outer fabrics: Italian;
tailoring: Dresden, Electoral Tailors' Workshop
Warp-faced satin, warp: crimson silk,
weft: light salmon silk, pinking pattern with cut
warp threads, the weft threads being left intact;
trim: silk velvet russet (formerly red)
Rüstkammer, inv. no. i. 0006

This short waisted doublet and breeches with a codpiece, made of crimson silk satin and silk velvet, combines influences from Spanish, Italian and French fashion during the period around 1580 to 1590. According to the 1591 inventory of the dresses left by Elector August of Saxony, they belonged to the Saxon electoral regalia: "1 pair of red silk satin hose and a finely pinked doublet, both trimmed with red velvet, plus a pair of red silk stockings, part of the Electoral Regalia". The main components of the electoral regalia, all of which were crimson in colour, were the electoral robe and the electoral hat of silk velvet with ermine, which could also be used by subsequent Electors if they were still in good condition.

The clothing worn under the electoral robe was made for each Elector in line with current fashion trends. In accordance with its function as the undergarment of the electoral regalia, this dress was decorated quite modestly – its ornamentation does not contain any gold or silver. The breeches still boast a codpiece. This was a feature which disappeared altogether from princely fashion around 1600. The velvet stripes and velvet edging applied diagonally on the hose in a herringbone pattern are incised at regular intervals along the unhemmed edges, so that the corners bend decoratively upwards. (→ page 22) Large-scale diagonal and horizontal stripe patterns appeared around 1580–1590 with new extravagant French and Italian breeches. Analysis of the silk satin fabric and the dyes employed has confirmed that Mexican cochineal (extract obtained from the chochineal insect) was used to dye the silk crimson.

The Electors of the Holy Roman Empire were only allowed to wear the electoral regalia at imperial assemblies in the presence of the Emperor. The size and stylistic features of this outfit, the only surviving dress belonging to the electoral regalia of any Elector, point to it having been made for Elector Christian I of Saxony. It is possible that Elector August, who often attended the Imperial Diet in person and played a decisive role there, had had this garment made for his son in case he died suddenly. Christian had very visibly accompanied his father to the Imperial Diet in Augsburg in 1582. Thereafter, religious differences in the Empire meant that neither Christian I nor Christian II had the opportunity to attend any Imperial Diet as Electors. JCvB

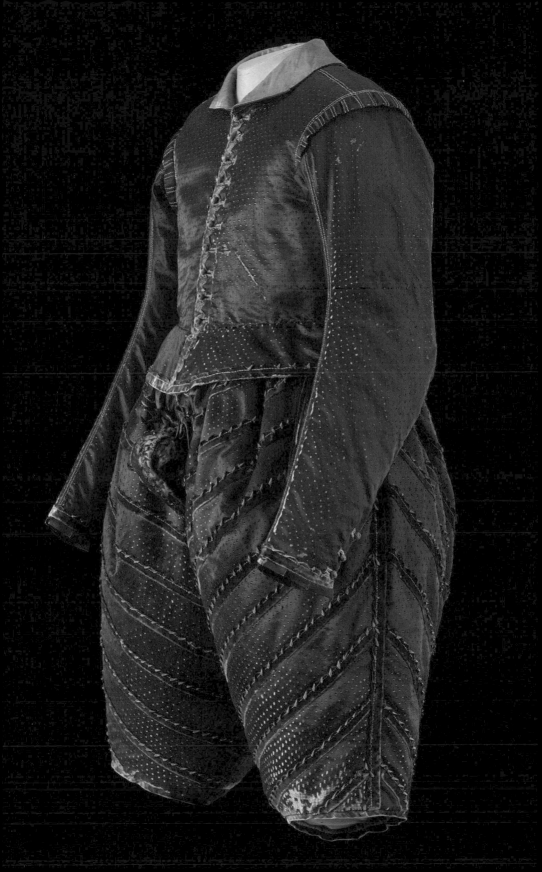

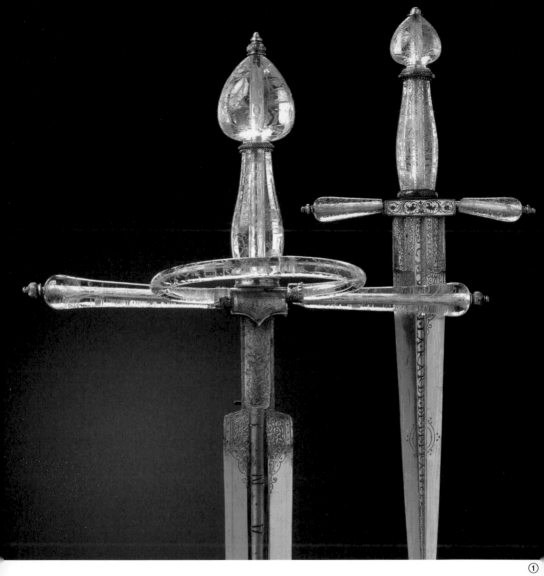

Showcase 15

Rapier-and-dagger garniture / Sword hanger

Milan 1601–1602 ① / Abraham Schwedler, Dresden 1624 ②
Iron, partly gilt, iron, rock crystal, wood, black velvet (replaced), silver;
sword hangers: leather, black silk, gold, diamonds
Rüstkammer, inv. nos. VI 0438; p. 0224 ① / i. 0462 ②

This rapier and dagger brilliantly combine two great traditions of the art metropolis of Milan: the craft of weapon making and the art of cutting, polishing, and engraving rock crystal. ① Duke Johann Georg (I) of Saxony brought these items from Italy in 1602 and gave them to his brother, Elector Christian II, as a gift in 1603. In 1624 Johann Georg I commissioned the embroidered sword hanger mounted with gold and diamonds from the Dresden goldsmith Abraham Schwedler. ② JCvB / CN

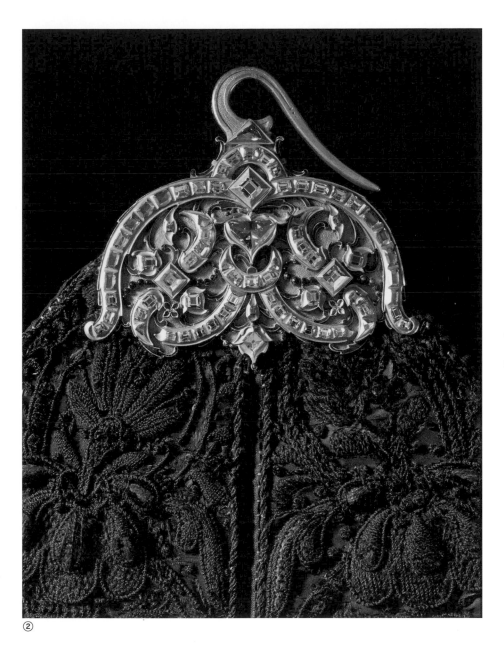

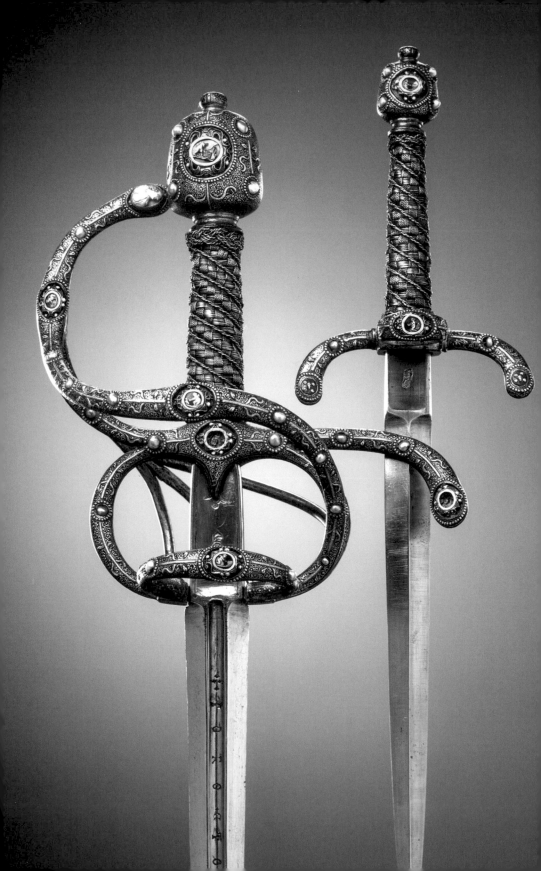

Showcase 16

Two rapier-and-dagger garnitures

Pearl garniture: Milan, c. 1600, rapier blade: Toledo ①
Iron, gold, silver; pearls, cameos; wood, velvet black (replaced);
sword hanger with waist belt: leather, silk velvet black, gold and
silver embroidery, pearls
Ruby garniture: Julius Caesar Marsilian, Milan, no later than 1609,
rapier blade: Milan ②
Iron, gold, silver; diamonds, rubies, enamel; wood, velvet black
(replaced); sword hanger with waist belt: leather, silk velvet,
gold and silver embroidery, diamonds, rubies
Rüstkammer, inv. nos. VI 0428; p. 0220; i. 0466; stirrups L 0278 ① /
VI 0429; p. 0219; i. 0470 ②

Among the items from the personal collection of Duke Johann Georg (I) are two
exquisite Milanese rapier-and-dagger garnitures that have been fully preserved. The
elaborate design of the sword hangers, as well as the accompanying straps, were
chosen to match the weapons. A rapier was carried in the loops of the hanger, which
was hooked onto the left side of the waist belt. The dagger was simply clipped into
the belt on the right-hand side.

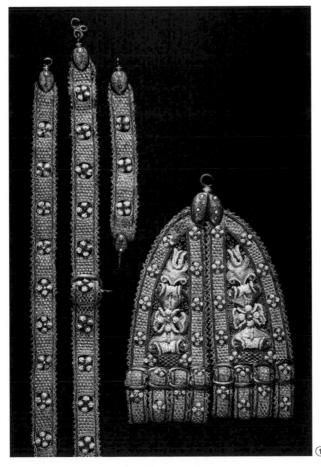

①

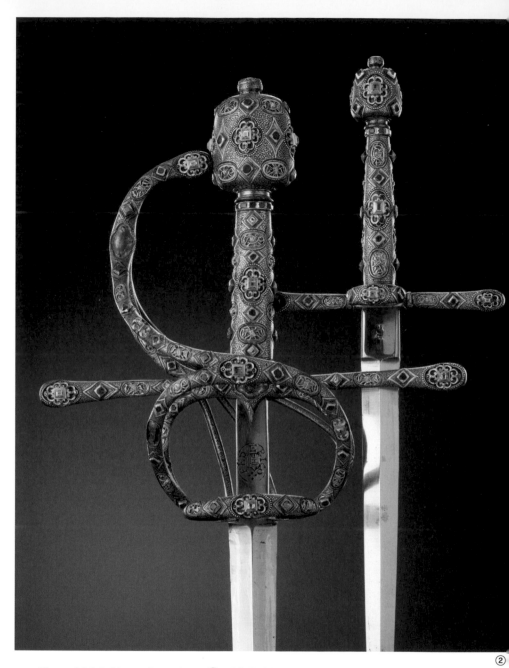

②

The gold-inlaid pearl garniture ① with "white stone pictures" was given to Johann Georg (I) by a certain Count de Fontes (probably Pedro Henriquez de Acevedo y Toledo, Conde de Fuentes, Governor of Milan) during his Grand Tour through Italy in 1601–1602. It is the largest surviving Milanese rapier-and-dagger garniture from the period around 1600. The ruby garniture ② with 45 diamonds (6 lost) and 179 rubies (6 lost) was purchased for him from the Milanese jeweller Julius Caesar Marsilian for 1,600 gulden and 20 silver groschen at the Easter Fair in Leipzig by his brother, Elector Christian II, in 1609. JCvB/CN

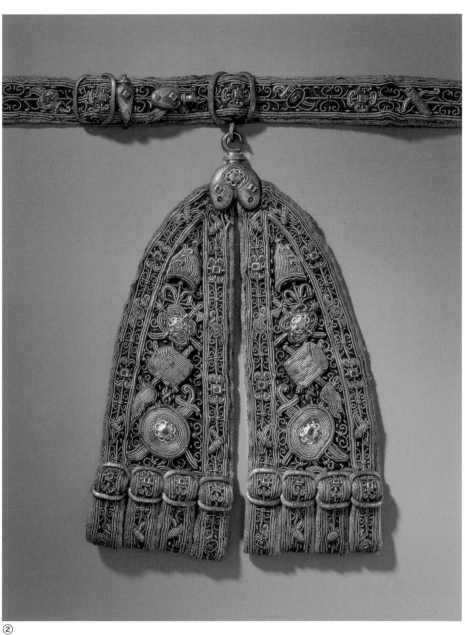

②

Showcase 17

Rapier / Sword hanger

Milan, c. 1600 ① / Dresden (?), 1617 ②
Iron, gold, enamel; diamonds, rubies; sword hanger with
waist belt: leather, gold wire, gold, enamel, diamonds
Rüstkammer, inv. nos. VI 0432 ① / i. 0412 ②

This rapier was given to Elector Christian II of Saxony in 1605 as a gift from Duke
Carlo Emanuele of Savoy. The iron hilt is covered with solid gold enamelled mounts
as well as 107 diamonds (11 lost) and 485 rubies (19 lost). ① The sword hanger
and belt made of knitted gold wire with 232 diamonds (8 lost) was given in 1617 by
Electress Magdalena Sibylla as a Christmas gift to her husband, Johann Georg I,
who assigned it to this ornate rapier. ② JCvB / CN

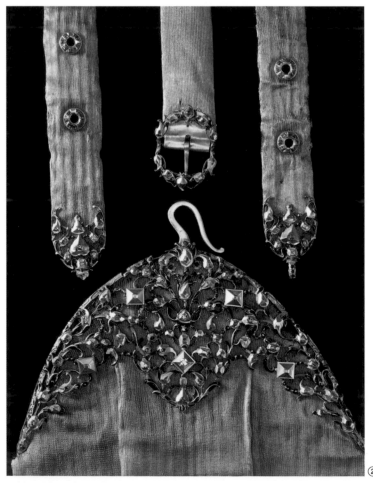

②

① →

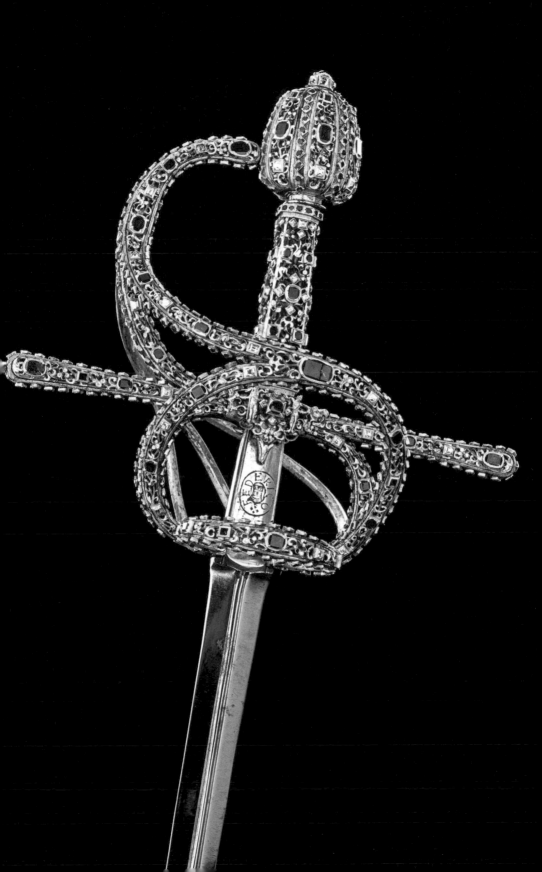

LUCAS CRANACH THE YOUNGER

Elector August of Saxony and his family

1564/1565
Signature: Serpent with folded wings
Oil on limewood

Elector August of Saxony
212 × 93.5 cm
Rüstkammer, inv. no. H 0094 ①

Electress Anna of Saxony, née Princess of Denmark
212 × 93.5 cm
Rüstkammer, inv. no. H 0095 ②

Duke Alexander of Saxony, from 1561 administrator of Merseburg
166 × 77.7 cm
Rüstkammer, inv. no. H 0096 ③

Duchess Elisabeth of Saxony, married Count Palatine Johann Casimir in 1570
166.3 × 81 cm
Rüstkammer, inv. no. H 0097 ④

①

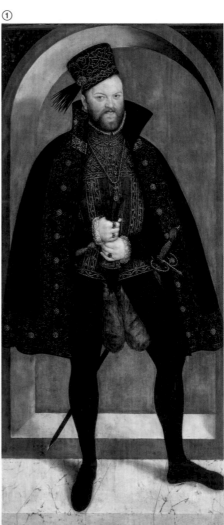

③

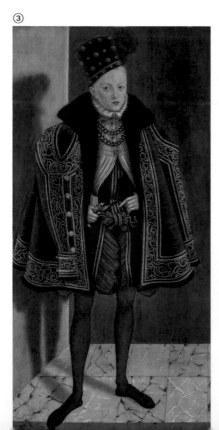

The electoral family is depicted wearing luxurious attire and costly jewellery. The garments of the Elector and his wife are carefully designed to match. The gold embroidery on their black outer wear has the same pattern. August's hat'band is decorated with the monogram of the couple, a mirrored letter "A", repeated at regular intervals. On his neck chain is the German royal eagle over the fire-iron from the symbol of the Order of the Golden Fleece and a portrait medal of Emperor Maximilian II., who succeeded his father, Ferdinand I, as Emperor on 25 July 1564. Anna is wearing two long gold and enamel chains, and gold chains with large precious pendants. Her gold neckband with diamonds was part of her dowry. Like her brother Alexander, Elisabeth is clothed completely in red. The gold embroidery on her dress has repeated lion motifs, which may perhaps allude to the Palatine Lion of her future husband. Electoral Prince Alexander is wearing a medal with the full armorial achievement of the Electors of Saxony and the circumscription "Alexander Dei Gracia Imbrato", not only linking the name of the prince to that of Alexander the Great, but also referring to his appointment as administrator of the Bishoprics of Merseburg and Naumburg. This portrait series was produced in connection with the visit to Dresden of King Maximilian II from 11 to 14 January 1564. JCvB

②

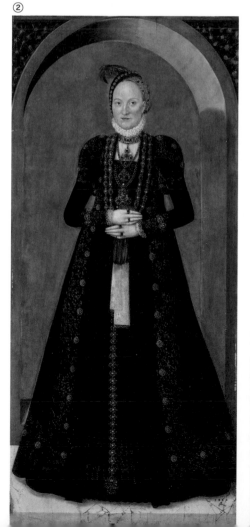

④

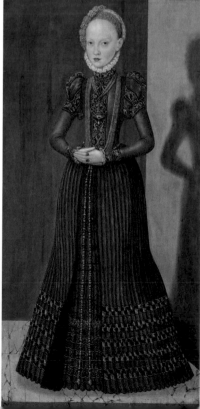

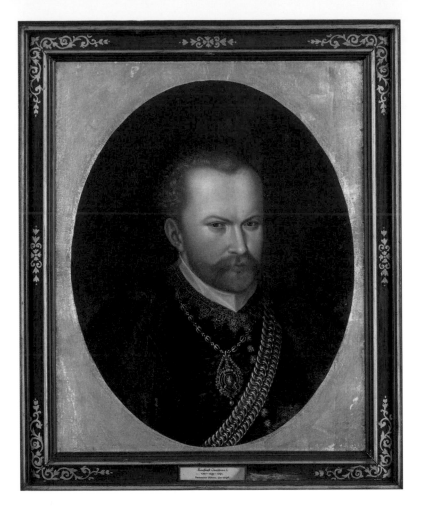

Wall exhibits 6–7

ANDREAS RIEHL THE YOUNGER
Elector Christian I of Saxony

> c. 1589–1591
> Oil on canvas; 81.9 × 68 cm (with frame)
> Rüstkammer, inv. no. H 0024

ANDREAS RIEHL THE YOUNGER
Electress Sophia of Saxony, née Margravine of Brandenburg

> c. 1589–1591
> Oil on canvas; 86.1 × 65.1 cm (with frame)
> Rüstkammer, inv. no. H 0025

The portrait of Elector Christian I shows him at the age of about 30, with delicate features. He wears an open cloak or coat with fur (sable?), a black doublet with geometrical patterns and colourful enamelled gold buttons, as well as a white filigree lace collar. A heavy gold chain hangs diagonally across his chest. On his

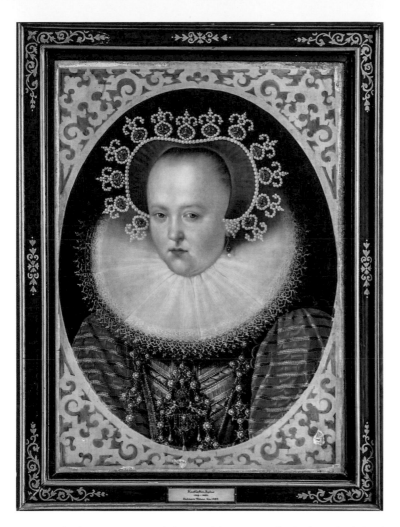

gold neck chain, the gem of the "Goldene Gesellschaft", which he founded in 1589, can be seen. Such a chain combined with a jewel pendant was known as a "Gesellschaft" ('association'). They were also commissioned by later Electors of Saxony and bestowed on a small circle of confidants – princes and courtiers.

Sophia, daughter of Elector Johann Georg of Brandenburg, is shown wearing a bright red dress with gold edging, a striking headdress decorated with pearls in the form of a diadem, as well as a large ruff. The gold chain mounted with precious stones has a large pendant with the letters "IHS", the pelican as an allegory for the expiatory sacrifice of Christ, as well as the alpha and omega symbol, all of which signify her piety. The painter of these two companion portraits, Andreas Riehl the Younger, worked for the court of the Electorate of Brandenburg. CN

Room 2

Parade dresses and weapons of the Electors Christian I (1560–1591) and Christian II (1583–1611) of Saxony

Christian II acceded to power in 1601. A portrait shows the 18-year-old Elector with the Electoral sword and a gilt rapier. Two comparable rapiers and daggers, including the rapier interred along with his father, Christian I, are exhibited next to the portrait. The wedding of Christian II and Hedwig of Denmark in 1602 is represented by her bridal slippers. Two garments belonging to Christian II himself – a blue and a dark red costume with silver trimmings – have also been preserved. He wore the dark red costume with punched heart motifs at the Imperial Court in Prague in 1610. Both garments display an imposing, innovative style. Sometimes such dresses were lined with particularly thick padding to accentuate their form. The knee-length breeches illustrate a turning point in fashion that took place around 1600: they no longer have a codpiece. The garments made for Christian II and the bridegroom's costume worn by his brother Johann Georg I in 1604 – the only surviving items of clothing from the period – demonstrate the increasingly international character of princely fashion during the first decade of the seventeenth century. JCvB

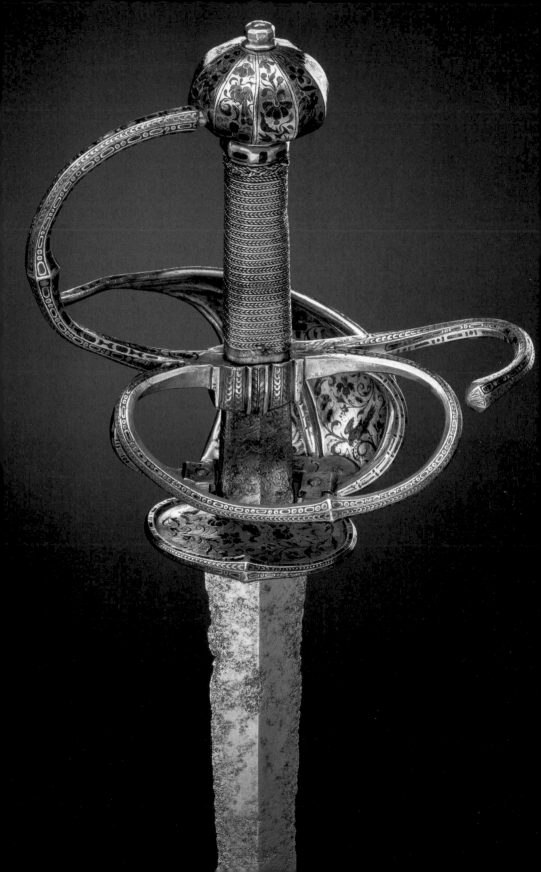

Two rapier-and-dagger garnitures / Sword hanger

Wendel unter der Linden, Dresden, c. 1590 ① ③
Dresden (?), 1st quarter of the 17th century ②
Iron, silver gilt; sword hanger with waist belt: leather, silver wire, silver, gilt;
iron (corroded), silver, gold, enamel, wood, blue velvet (originally black)
Rüstkammer, inv. nos. VI 0342; p. 0184 ① / i. 0354 ② / VII 034; p. 0159 ③

The rapier-and-dagger garniture ③ is decorated with coloured champlevé enamel
in the form of tendrils, flowers, mythical creatures, and birds. The rapier was laid
in the coffin of Elector Christian I in 1591. In 1920, the weapon was removed and
reunited with the dagger that had remained in the Dresden Rüstkammer. The sword
hanger and the belt ② are covered with a fine knit of solid silver wire, and the
mounts are decorated with silver-gilt lions' heads. JCvB / CN

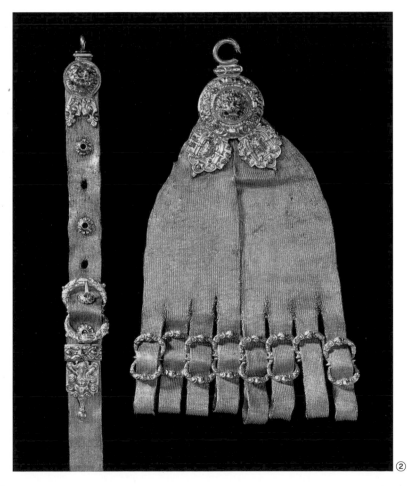

②

Room 2

Bridal slippers of Princess Hedwig of Denmark for her wedding ceremony with Elector Christian II of Saxony in Dresden in 1602

Pair of slippers
Danish (?), 1602; Initials "CH" (Christian and Hedwig)
Crimson silk velvet, silver embroidery, sequins, leather
Length 21.6 cm; heel height 5 cm
Rüstkammer, inv. no. i. 0104

These lady's slippers with small block heels are covered with prestigious crimson silk velvet and embroidered with silver tendril motifs and gold sequins. The initials CH under a crown, executed in silver relief embroidery, stand for the electoral couple Christian II of Saxony and Hedwig, née Princess of Denmark. The slippers, designed as overshoes, were probably part of Hedwig's outfit for her wedding to Christian II, who had acceded as Elector in 1601, in Dresden in September 1602. The silver is equivalent to the wedding colour white, while the crown refers to the bride's royal descent. Hedwig and her mother were taken to the capital of Electoral Saxony in a carriage lined with red gold-woven silk velvet and shaped like a ship. On their arrival, the bridegroom personally lifted the two ladies out of the carriage. For the bedding ceremony in the Hall of the Giants, the bride and groom were arrayed in matching splendid attire: the bridegroom wore a "white dress of silver" and a cloak of black velvet lined with "silver and white" fabric; the bride, "like her lord bridegroom" was also dressed in white and silver. Christian II and Hedwig were publicly laid together on a newly purchased pearl-embroidered state bed. JCvB

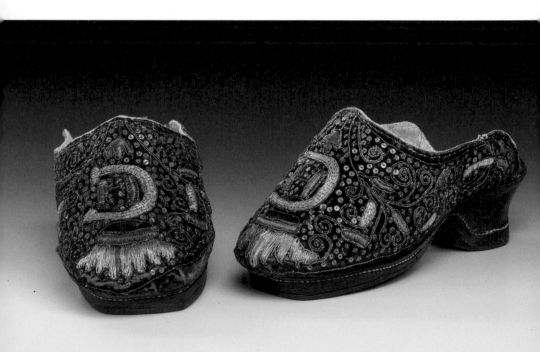

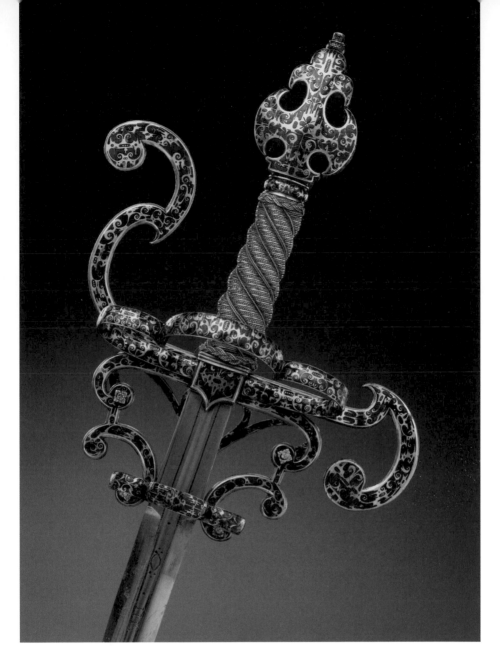

Showcase 20

Rapier belonging to Duke August of Saxony

Marx Bischhausen (?), Dresden, c. 1604–1610
Iron, silver, enamel, silver wire
Rüstkammer, inv. no. VI 0433

This rapier is in imitation 'oriental' style. The solid silver hilt features Moorish-style ornamentation in blue champlevé enamel. The pommel is decorated with a small turban. CN/JCvB

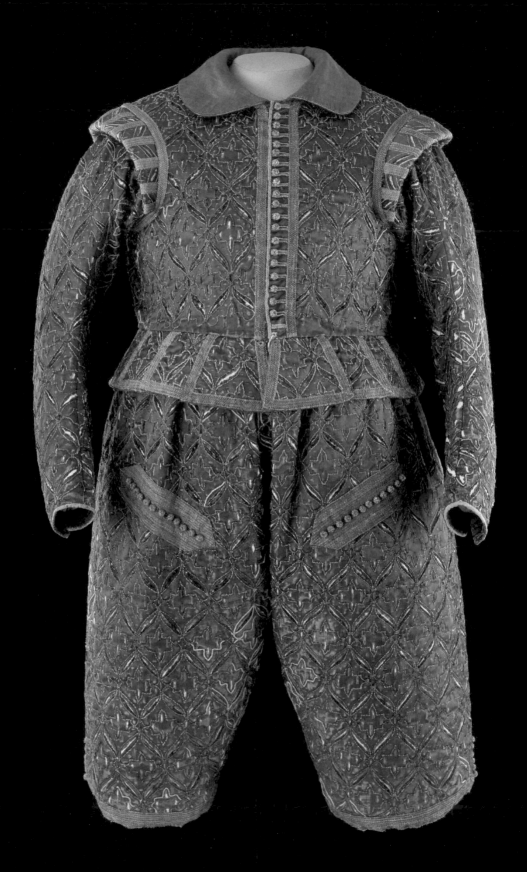

Parade dress of Elector Christian II of Saxony

Doublet and breeches
c. 1607–1610; outer fabric: Italian;
tailoring: Dresden, Electoral Tailors' Workshop;
trimmings: probably Saxon; fustian stamped: "Biberach"
Blue silk satin, slash and pinking pattern; silver trimmings;
natural-coloured and blue silk taffeta; linen, cotton fleece, fustian
Rüstkammer, inv. no. i. 0007

This dress in elegant blue consists of a doublet with flat collar and padded shoulder wings in the Spanish-Italian fashion as well as thick padded breeches in the French style, known as galligaskins. It is set off by an abundance of silver trimmings. The blue-and-silver buttons, of which there were originally 71, are both functional and decorative. The jaunty slashes forming lozenge shapes reflect contemporary weaving patterns (→ page 70) and can also be seen on the portrait of Christian II (wall exhibit 9). JCvB

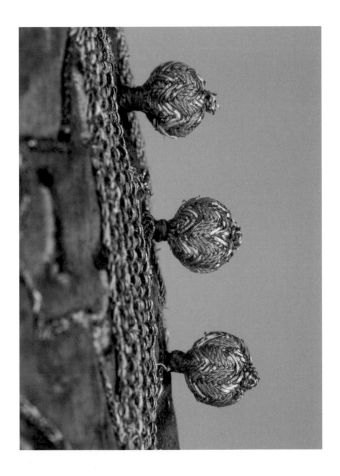

Room 2

Parade dress of Elector Christian II of Saxony

Doublet and breeches
1610; outer fabric: Italian (?);
tailoring: Dresden, Electoral Tailors' Workshop;
trimmings: probably Saxon
Brownish violet silk satin, pinked, punshed and slashed pattern;
silver trimmings; natural-coloured silk taffeta; linen; cotton fabric
Rüstkammer, inv. no. i. 0009

This brownish violet outfit, decorated with punched hearts and slashes over a beige lining as well as silver trimmings, was worn by Christian II when he was invested with the disputed territories of Jülich, Cleves, and Berg by Emperor Rudolf II in Prague in 1610. It consists of a short doublet with small standing collar and padded shoulder wings, and bulging knee-length breeches. A drawing by Johann Fasold in the Dresden Kupferstich-Kabinett shows Christian II during his investiture. He is depicted kneeling bare-headed before the enthroned Emperor in the audience chamber of Prague Castle, swearing fealty while touching the blade of the sword being held out to him. Over his dress in the style of the surviving original he wears a draped knee-length Spanish cloak. JCvB

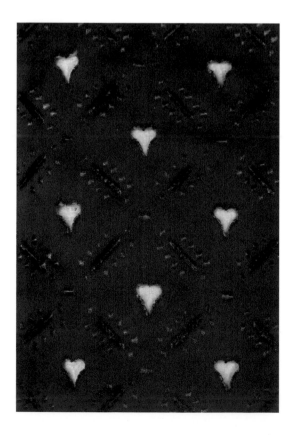

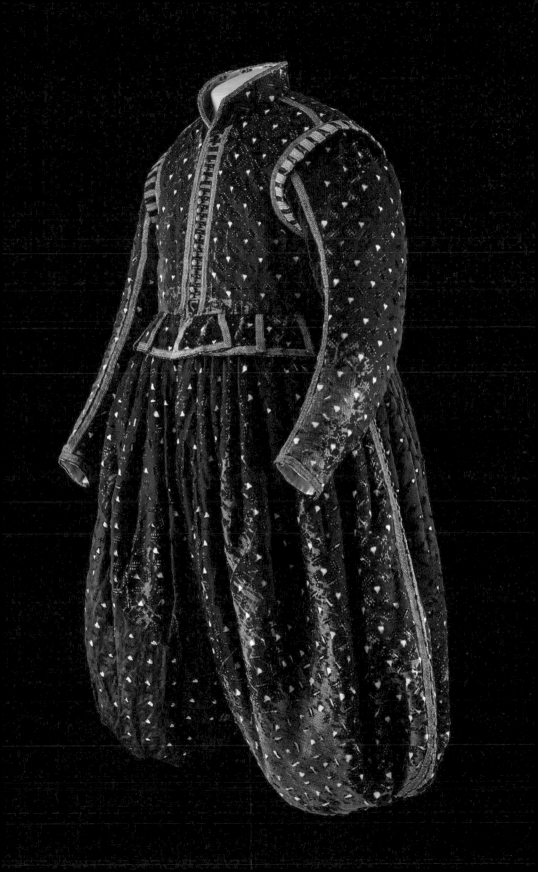

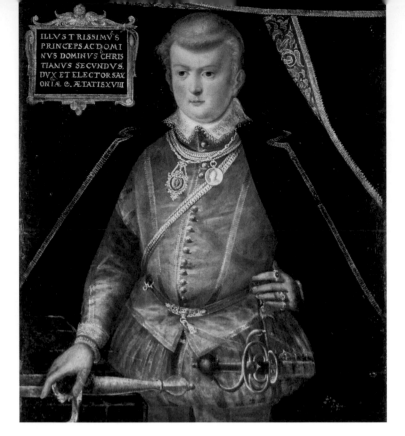

Wall exhibit 8

PROBABLY ZACHARIAS WEHME

Elector Christian II of Saxony

1601
Oil on canvas; 101 × 83 cm
Signed: "ILLVSTRISSIMVS PRINCEPS AC DOMINVS DOMINVUS
CHRISTIANVS SECVNDVS. DVX ET ELECTOR SAXONIÆ C. ÆTATIS XVIII"
Rüstkammer, inv. no. H 0070

This portrait shows the 18-year-old Elector Christian II of Saxony, as yet still sleek and slender, but looking a little unsure of himself, shortly after his accession to power in the year 1601. His right hand touches the electoral sword of 1566, while his left hand rests on his hip, displaying bulky gold rings with precious stones. The young Elector is dressed in a costume influenced by Italian and French fashion: a black coat or cloak hanging casually over his shoulders along with a waisted doublet and puffed trunk hose with cannions of red silk. All parts of his costume are decorated with gold trim. On the golden chains around his neck are the gem of the "Goldene Gesellschaft" of his father Christian I of Saxony and a portrait medal of Emperor Rudolf II (?). The silver gilt rapier inherited, along with other ceremonial weapons, from his father Christian I, is suspended in a broad sword hanger of the latest Italian design, in keeping with his costume. JCvB/CN

Elector Christan II of Saxony and his wife Hedwig of Denmark

Dresden, c. 1620–1625
Reverse: brocade paper, Georg Christoph Stoy, Augsburg, c. 1709–1750
Oil on wood; ca. 23 × 13.8 cm (with frame, replaced)
Rüstkammer, inv. nos. H 0180 ① / H 0181 ②

These two small panel paintings show Elector Christian II of Saxony, who died without issue in 1611, and his wife Hedwig of Denmark in widow's attire. The pendant paintings probably originally formed a marriage diptych in keeping with the tradition of small private portraits in the Renaissance. Such miniature portraits were intended for personal use and they were often given away as gifts and tokens of honour. VP

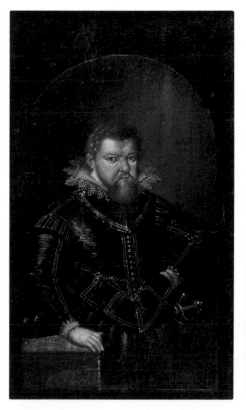

Room 2

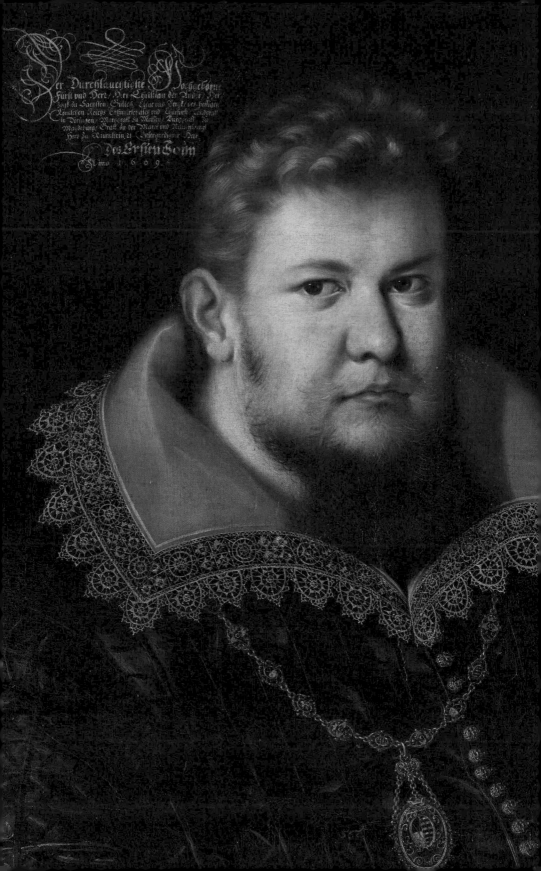

Der Durchlauchtigte Hochgeborne
Fürst und Herr, Herr Christian der Ander, Herr
zogk zu Sachssen, Gülich, Cleve und Bergk, des heiligen
Römischen Reichs Erstmarschalck und Churfürst, Landgraff
in Döringen, Marggraff zu Meissen, Burggraff zu
Magdeburg, Graff zu der Marck und Ravensberg,
Herr zu Ravenstein, ze. Oestergeborner Herr.

Jm Ersten Jahr
Anno 1 6 0 9.

PROBABLY CHRISTIAN SCHIEBLING

Elector Christian II of Saxony

Before 1640
Signed and dated: "Der Durchlauchtigste Hochgeborne Fürst und
Herr Herr Christian der Ander Herzogk zu Sachssen, Gülich, Cleve
und Bergk des heiligen Römischen Reichs Ertzmarschalch und
Churfürst Landgraff in Döringen Marggraff zu Meissen Burggraff zu
Magdeburg Graff zu der Marck und Rauenburgk Herr zu Rauenstein
etc. [?] Unser gnedigster Herr Des Ersten Sohn Anno 1609."
Oil on canvas; 62.6 × 50 cm
Rüstkammer, inv. no. H 0069

This bust portrait shows the 26-year-old Elector Christian II of
Saxony as a man of robust stature with curly blond hair and a beard.
He wears his green doublet decorated with geometrical slashes, such
as can be seen in the blue and silver costume of Christian II (show-
case 21), along with a large white flat collar with a broad border of
fine lace. Around his neck he wears the gold and enamel chain and
pendant of the "Wappengesellschaft", which he commissioned upon
his accession in 1601. This portrait may be modelled on the full figure
portrait of Christian II by Zacharias Wehme (destroyed), which used
to hang in the Pretiosensaal of the Grünes Gewölbe. CN

Room 2

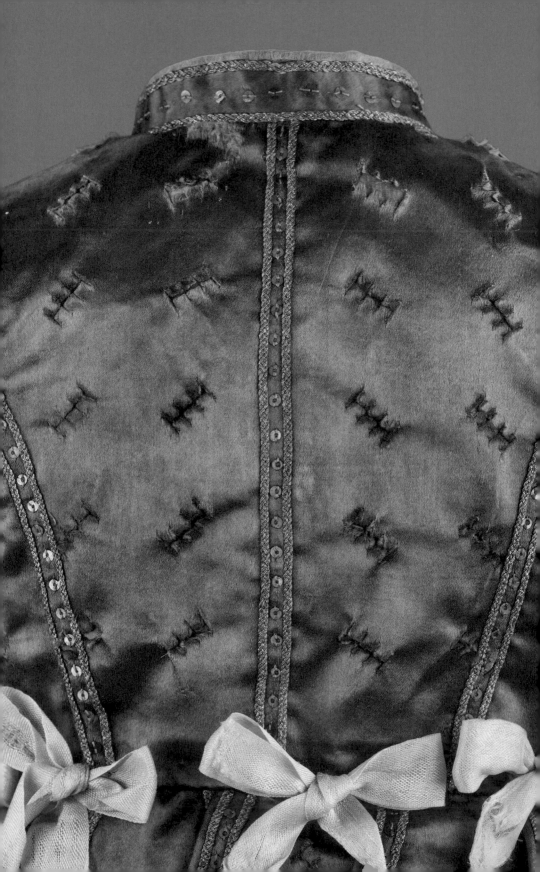

Room 3

Parade dresses and weapons of Elector Johann Georg I (1585–1656) and Electress Magdalena Sibylla (1587–1659) of Saxony and their children

The marriage of Johann Georg I and Magdalena Sibylla produced four sons and three daughters, signifying both dynastic success and personal fulfilment. Their family cohesion was expressed in portraits through their clothing and gestures of affection. Here, Magdalena Sibylla displays her fashion consciousness by wearing brightly coloured garments, filigree lace, precious gold jewellery and pearls, a clearly defined hairstyle and cosmetic highlights. It is thanks to her that garments belonging not only to her husband but also to herself and two of her children were preserved. The suit made for Prince Johann Georg (II) at nearly four years of age was his first boy's dress. Three dresses belonging to Magdalena Sibylla and one dress of her youngest daughter Magdalena Sibylla are now the only preserved princely ladies' garments dating from the first half of the 17th century. Thus, Dresden possesses a treasure of European early Baroque ladies' fashion. JCvB

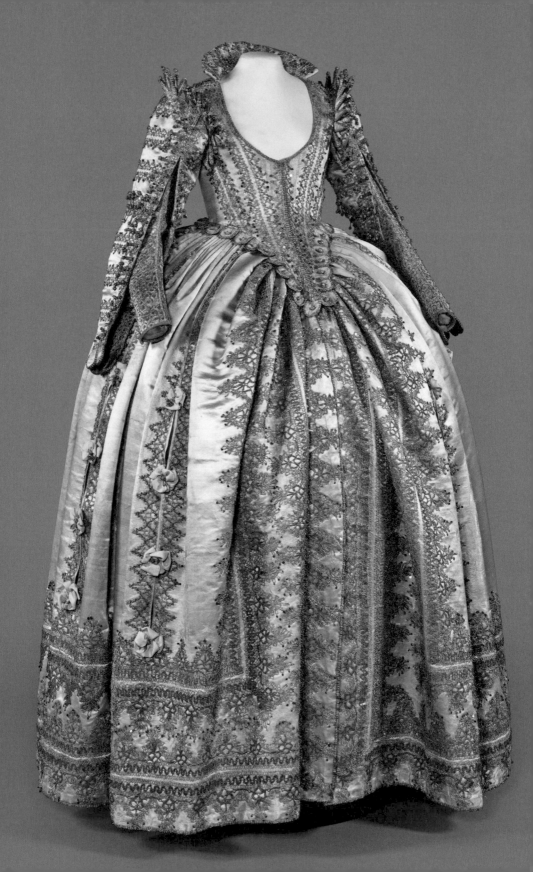

Parade dress of Electress Magdalena Sibylla of Saxony

Bodice and skirt
c. 1610–1620, outer fabrics: Italian;
tailoring: Dresden, Electoral Tailors' Workshop;
bobbin lace and trimmings: Saxon
Golden yellow and safflower red silk satin; gold embroidery;
gold and silver trimmings; gold and silver lace; sequins,
taffeta ribbons, silk pompoms; fishbone rods
Rüstkammer, inv. no. i. 0045

This golden yellow and safflower red dress with gold and silver lace follows the style, the nuanced colours, and the sophisticated ornamental details of Italian ladies' fashion in the period around 1590–1620. It combines French, Italian, and Spanish fashion elements. The narrow-waisted pointed bodice has a low neckline and is decorated with densely packed narrow rows of gold and silver lace. It closes at the front with concealed hook-and-eye fastenings. The skirt is attached to the bodice by numerous gold and silver passementerie buttons. The somewhat stiffened bodice is an early form of the so-called Schneppentaille (a tight bodice with a tapering extension at the front), which was to dominate ladies' fashion until the middle of the seventeenth century.

The skirt – an overskirt – is open at the front and is attractively decorated with gold and silver lace running in several bands of various width, into which drop-shaped silver sequins are worked. Originally, a second sumptuous skirt (which has not survived) worn underneath would have been visible through the front slit and

Room 3

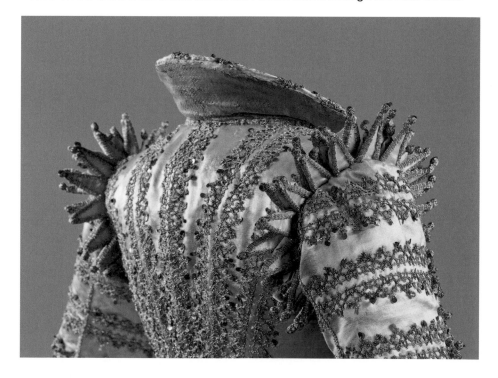

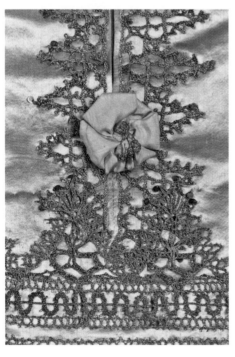

the long slashes in the overskirt held together with ribbon roses.

The high collar, whose lining was covered by a white linen lace collar, was unknowingly sewn on back to front during a previous restoration. The graceful star-like shoulder ornaments are borrowed from the bridal and festive dresses of the Venetian aristocracy. The pointed tips are strikingly decorated with bright red silk pompoms. The tight-fitting safflower red sleeves are fastened with buttons at the wrist. They are embroidered all over with fish scales and stars. The detachable golden-yellow wing sleeves on top are decorated with lace and many small trimmings of gold and silver threads.

Accessories worn with the dress would probably have been a high-standing collar of fine white lace, lace cuffs of the same type, set off with precious gold and pearl jewellery.

The queens and princesses of the English and Danish royal families, in particular, as well as Maria de' Medici, Duchess of Florence and Queen of France, were pioneers of the fashion represented by this dress. No other surviving original pieces have survived in such splendid quality, completeness, and excellent state of preservation. JCvB

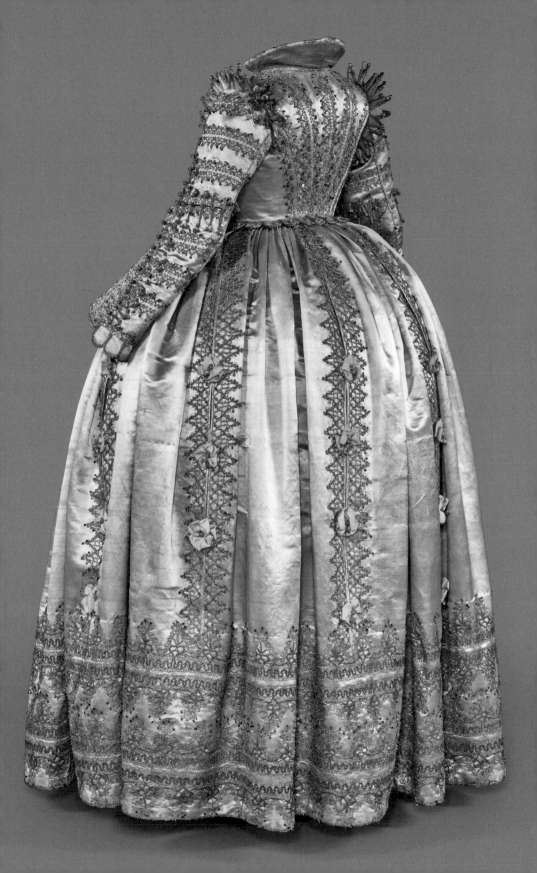

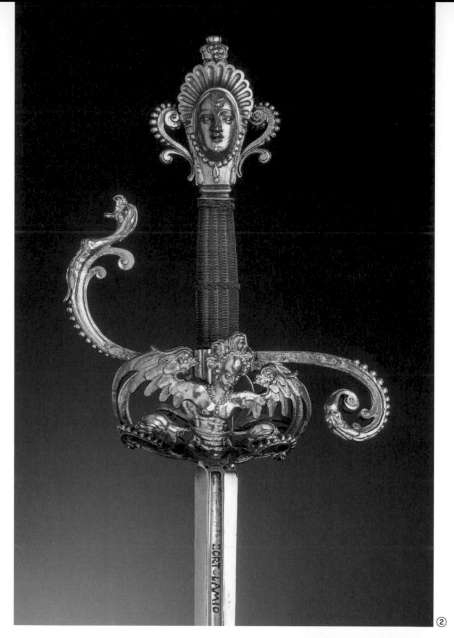

②

Showcase 25

Rapiers, daggers, and sword hangers

Dresden, c. 1600–1610
Blades: Solingen
Iron, brass, gold, silver; wood, black velvet (partly
replaced); sword hangers: leather, black velvet (partly
replaced), gold and silver embroidery
Rüstkammer, inv. nos. VI 0418 ① / VI 0419;
p. 0007 ② / i. 0363 ③] / VI 0232; p. 0112 ④ /
VI 0341; p. 0058; i. 0358 ⑤ / VI 0233; p. 0160 ⑥

⑥

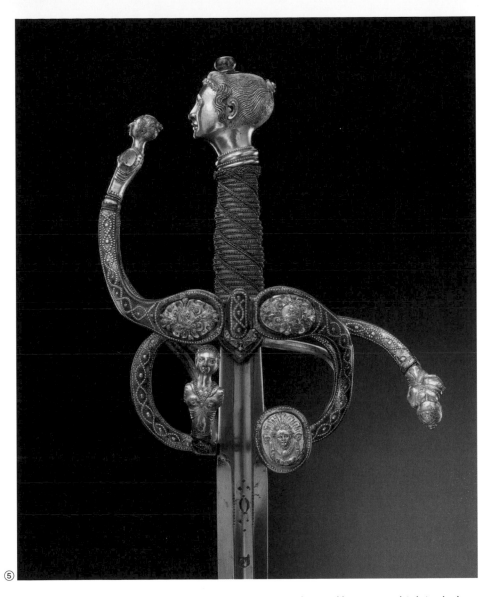

⑤

This fine group of Dresden rapiers, daggers, and sword hangers, which includes a small sword hanger for a prince, has figural decor referring to both classical antiquity and the Bible, in which women are depicted in a contradictory way: on the one hand, womanhood is associated with beauty and the Muses, as well with the caring wife and mother, while on the other hand, women are represented as evil seductresses – Medusa, the Sirens and the Babylonian Woman ⑥.

The rapier with two angel faces on the pommel, quillons "with a dragon's head" on the ends, and a shell guard depicting a flying Siren, was a gift from Electress Hedwig to her husband Christian II of Saxony for Christmas 1610 ②. The rapier-and-dagger garniture with female heads and female busts was given by the widowed Electress Sophia to her second-eldest son, Duke Johann Georg, as a New Year's gift in 1601 ⑤. JCvB

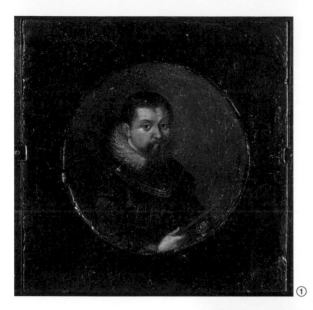

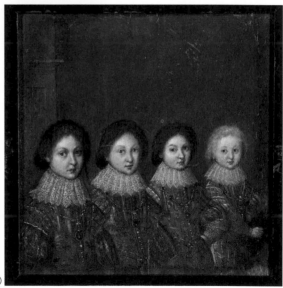

Showcase 26

Elector Johann Georg I and his wife Magdalena Sibylla of Saxony with their sons and daughters

Dresden, c. 1625
Oil on canvas and wood; ca. 17.4 × 16.9 cm (with frame, replaced)
Rüstkammer, inv. nos. H 0182 ① / H 0183 ②

The two small square wooden panels show the portraits of Elector Johann Georg I of Saxony ① and his second wife, Magdalena Sibylla ②. The backs of the panels show, in order of age, the seven of the couple's ten children who were to reach adulthood.

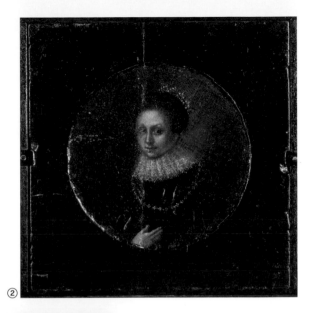

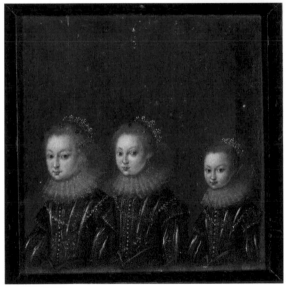

②

The four sons are assigned to the father ①: they are the future Elector Johann Georg II, as well as the later founders of the collateral lines of Saxe-Weissenfels, Saxe-Merseburg and Saxe-Zeitz, August, Christian, and Moritz. The reverse of the panel with the mother's portrait shows the daughters Sophia Eleonora, Maria Elisabeth, and Magdalena Sibylla ②.

The children are uniformly dressed in keeping with the contemporary fashion worn by their parents. Their luxurious red garments are smaller versions of the fashionable adult attire of the 1620s. The portraits of princes are a clear demonstration that after the death of the previous Elector, Christian II, who had no heirs, the continuation of the Albertine line of the House of Wettin in the Electorate of Saxony was now safely assured through Johann Georg I. VP

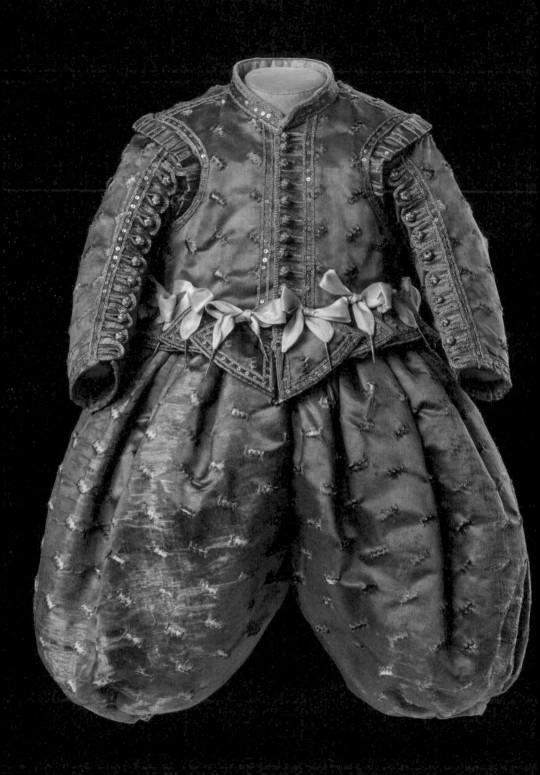

First boy's dress of the Electoral Prince Johann Georg (II) of Saxony

Doublet and breeches
1617 (?), outer fabric: Italian;
tailoring: Dresden, Electoral Tailors' Workshop
Dark pink silk satin, pinking- and slashing,
lemon-yellow silk taffeta, pink silk ribbons,
gold trimmings, sequins
Rüstkammer, inv. no. i. 0019

This boy's dress, consisting of a doublet and knee-length breeches made of dark pink satin decorated with pinked cuts and slashes, was probably the first set of ceremonial garments worn by Elector Johann Georg (II) in accordance with adult male fashion. In terms of its material, colour, style, and decoration, it corresponded to a "peach-blossom-coloured" costume worn by his father, Johann Georg I. The English-style garments worn by father and son followed the example of the Danish royal house, with whom they remained in close contact, not least via the Dowager Electress, Hedwig.

The prince's dress, trimmed with gold borders, sequins and passementerie buttons, has a close-fitting, padded doublet with small trapezoidal laps. An under-layer of lemon-yellow taffeta highlights the cut and slash design (→ page 84). The pink bows at the tapered waist did not have a fastening function, but were purely decorative. The occasion prompting the production of the two magnificent dresses that have survived together may have been the introduction of the Electoral Prince at his father's side during the visit of Emperor Matthias to Dresden in 1617, which lasted several weeks. JCvB

Room 3

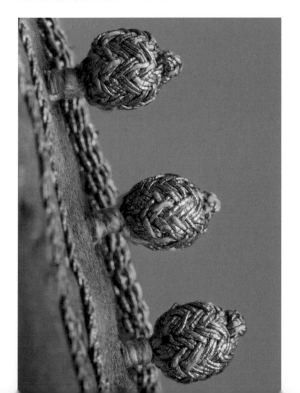

95

Parade dress of Saxon Electoral Princess Magdalena Sibylla

c. 1634, outer fabric: Italian;
tailoring: Dresden, Electoral Tailors' Workshop (?)
Damask, purple silk, gold thread brocaded; gold trimmings;
padding on left side of the back: cotton fleece, wool, linen,
approx. 4 cm thick; front edges with concealed lacing;
lining: blue taffeta
Rüstkammer, inv. no. i. 0047

This overdress made of purple damask, decorated with gold-brocaded floral sprigs of various sizes arranged in a diamond pattern, was part of a multi-piece set of lady's garments, as evidenced by portraits of the princess painted at the time of her marriage to the Danish Crown Prince Christian in Copenhagen in 1634. It also included a chest bib or corset with a tapered bodice and an additional skirt. The dress would also have been worn with a shirt or blouse with wide sleeves, as well as a broad lace collar and cuffs. Braided edging and passementerie buttons are attractively applied to the sleeves and back. The padding on one side of the back, behind the left shoulder, is evidence that the wearer suffered from a curvature of the spine that deformed her rib cage. Clues to such a physical anomaly can be gleaned from various portraits of Magdalena Sibylla from her childhood onwards, where her décolleté is always covered. JCvB

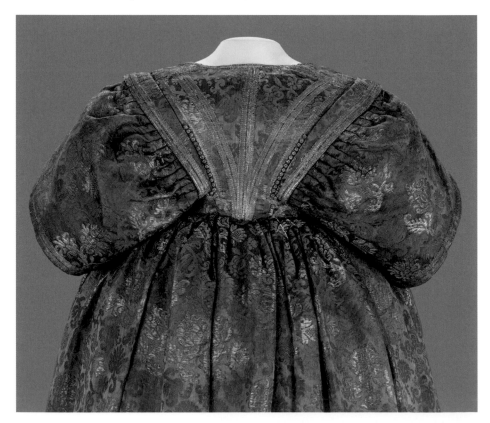

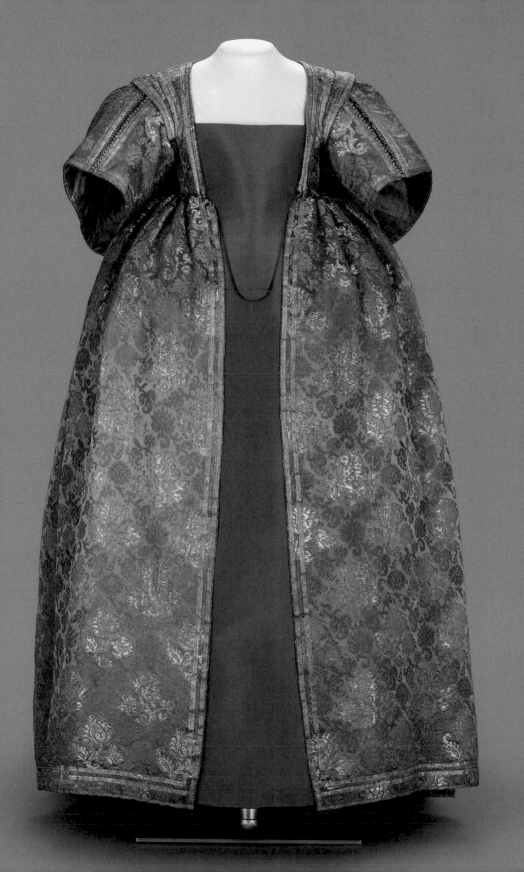

Parade dress of Electress Magdalena Sibylla of Saxony

Bodice and skirt
c. 1650, outer fabric: Italian;
tailoring: Dresden, Electoral Tailors' Workshop;
bobbin lace and trimmings: Saxon
Yellow silk satin; silver embroidery with sequins; silver lace;
silver trimmings; fishbone rods, linen, taffeta
Rüstkammer, inv. no. i. 0043

This French style lady's dress, described in the old inventories as "lemon-coloured", consists of a long wide skirt and a bodice. The ornate silver embroidery with flowers and bows incorporates 78,900 silver sequins, some of which had gone missing and were replaced during restoration. The lace-up bodice with shoulder-width décolleté and tapered waist is reinforced with fishbone rods. Several strips of silver lace accentuate the design. JCvB

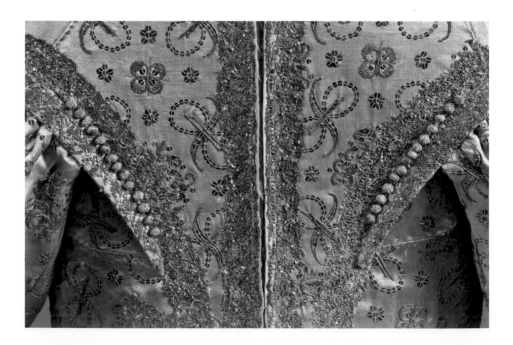

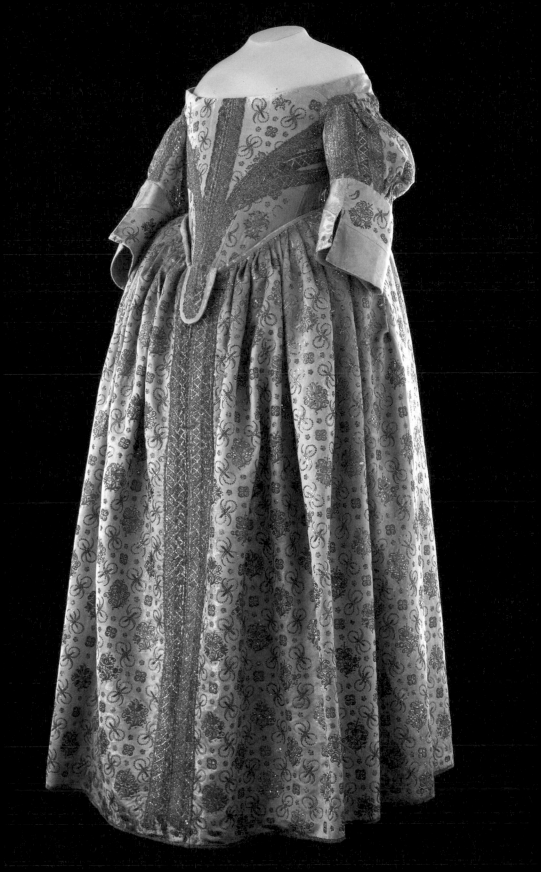

Parade dress made for Electress Magdalena Sibylla of Saxony

Bodice and skirt
c. 1650; outer fabric: Italian;
tailoring: Dresden, Electoral Tailors' Workshop;
bobbin lace and trimmings: probably Saxon
Lampas, amaranth red silk, gold lamé thread, gold thread lancé; gold lace;
gold trimmings; lace-up fastening, fishbone rods; lining: yellow taffeta
Rüstkammer, inv. no. i. 0042

This dress made of "amourant [silk] and golden fabric with gold lace" is one of the most precious garments owned by Magdalena Sibylla. It features a small-scale asymmetrical scattered-flower pattern in keeping with contemporary fashion. The fabric of amaranth red silk is covered all over with gold lamé threads and with patterns formed by gold threads with a yellow silk core. The voluminous skirt with its elaborate train employs particularly large amounts of the luxurious brocade-like gold fabric. Broad strips of gold bobbin lace accentuate and decorate the lace-up bodice and the front of the skirt. The dress would have been complemented with a white lace collar along the off-shoulder neckline, and by long puffed sleeves. This sumptuous dress would have called for jewellery featuring pearls and precious stones, and a precious brooch shaped into a bow at the décolleté would have been de rigueur. The dress was evidently intended for an outstanding event: this may well have been the double wedding of the electoral couple's younger sons, Christian

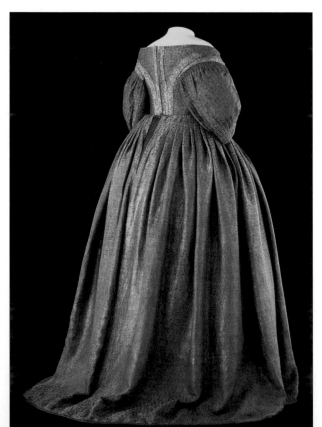

and Moritz, in Dresden in 1650. The purchases required for that event were still an extraordinary challenge so shortly after the end of the Thirty Years' War, when money was in short supply due to the devastated economy and the tribute payments to Sweden, where at the same time luxurious princely attire influenced by French fashion was booming at the royal court. JCvB

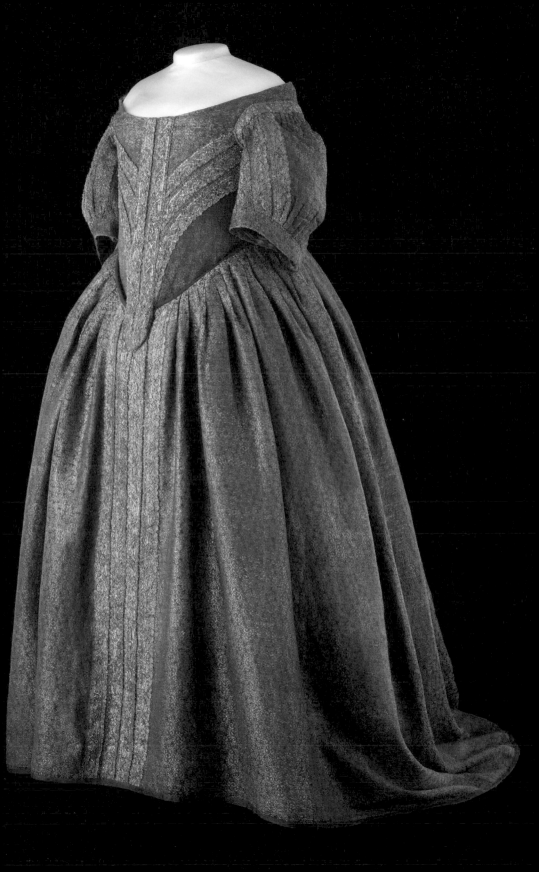

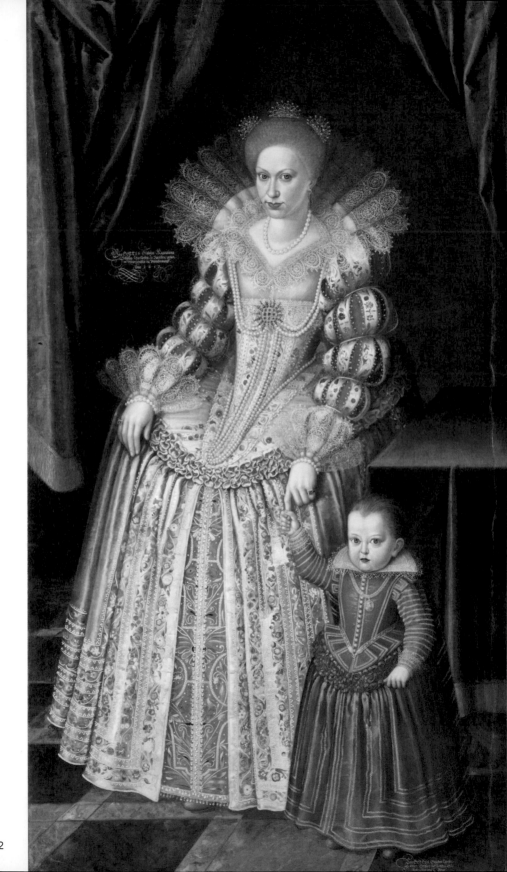

Electress Magdalena Sibylla of Saxony with her son Christian

German, 1617
Oil on canvas; 220 × 120 cm
Inscribed: "Von GOTTES Gnaden Magdalena Sibylla Churfürstin
zu Sachssen, geborne Marggräfin zu Brandenburgk. Anno 1617"/
"Von GOTTES Gnaden Christianus, Hertzog zu Sachssen Gülich
Cleue und Bergk"
Gemäldegalerie Alte Meister, inv. no. 99/45

Magdalena Sibylla, born Margravine of Brandenburg and Duchess of Prussia, from 1606 Duchess and from 1611 Electress of Saxony, is depicted in a full-length portrait along with her two-year-old son, Electoral Prince Christian, who is holding her finger. The portrait is a pendant to the portrait of Elector Johann Georg I of Saxony, untraced since 1945, in which he is shown in the bridegroom's dress which he wore at his wedding to Magdalena Sibylla in Torgau in 1607.

The Electress shows herself to be highly fashion-conscious, being dressed in the latest French style. Well versed in the apothecary's art, she appears with her curly blonde hair piled up, and wearing white face pomade and rouge on her cheeks and lips. Thanks to her wide-ranging contacts among the princely houses of Europe, she was able to pick up on the impulses of the fashion icons of the time who were emancipating themselves from Spanish fashion – namely, Maria de' Medici, Duchess of Florence, as wife of Henry IV Queen of France; and Anne of Denmark, as wife of James I Queen of England and Scotland.

The Electress is wearing a white and safflower red dress with colourful embroidered flowers, lavish gold, diamond, and pearl jewellery, as well as filigree white linen lace. Ladies' dresses of the fashion shown here were composed of various parts – bodice, overskirt, second skirt or apron, and sleeves. They could be combined with each other in different ways. The sleeves have decorative slashing and a series of puffs along the arm. The narrow bodice has a protruding, tapering extension at the front. The skirt, supported by a drum-shaped farthingale ("vertugade en tambour"), has a wide shelf-like overskirt consisting of several layers with tubular pleats. This type of French-style drum-shaped skirt is said to have been taken to a width of 1.40 m by the English Queen, Anne of Denmark. The large lace ruff, a particularly high example of which was worn by Maria de' Medici, has gone down in fashion history as the "Medici collar" or "Stuart collar". The star-shaped diamond-studded brooch on her chest was still being faithfully worn by Magdalena Sibylla in 1629, despite it having long gone out of fashion by then.

Her two-year-old son Christian is wearing a girl's dress, as was customary for a boy of his age, and a gold chain with his father's portrait medallion has been placed around his neck. With his right hand, he trustingly grasps his mother's index finger, while his left is clenched in a small fist. JCvB

Room 3

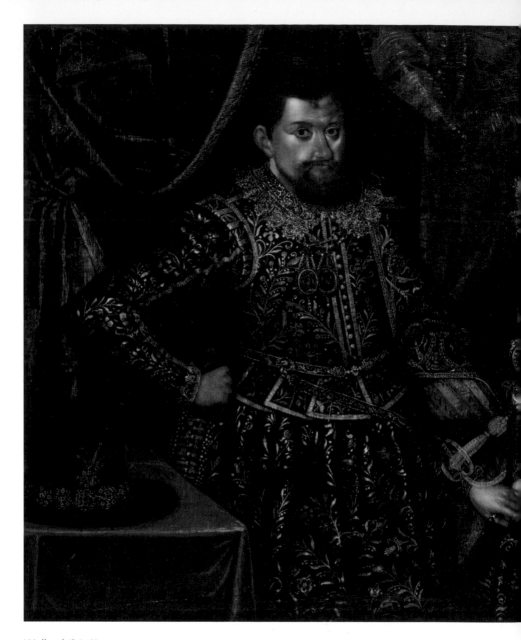

Elector Johann Georg I of Saxony and Electress Magdalena Sibylla, née Margravine of Brandenburg and Duchess in Prussia

German, after 1617
Oil on canvas; 75.5 × 112.5 cm
Gemäldegalerie Alte Meister, inv. no. 99/46

This knee-length double portrait depicts the lavishly dressed couple hand in hand. The Elector and Electress wear matching garments made of black silk with floral motifs in gold embroidery and with gold edging, emphasising the personal bond

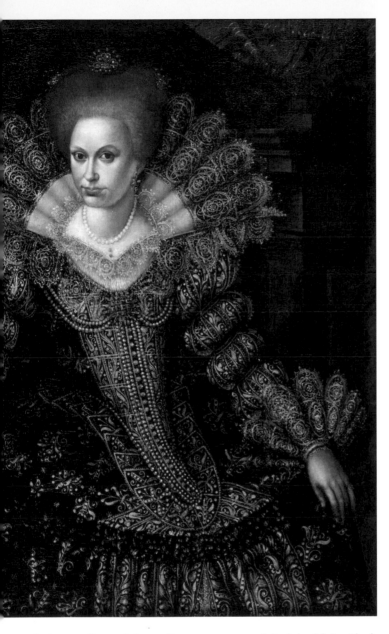

between them. Johann Georg wears a waisted doublet with short laps, voluminous breeches with opulent gold trimmings on the side seam, as well as a white lace collar and cuffs. He holds a golden rapier inlaid with precious jewels and wears two gold enamelled "Gesellschaftsketten" (chains with jewelled pendants) – one of which had been commissioned by his deceased brother, Christian II, and the other by himself upon his accession as Elector. The dress worn by Magdalena Sibylla has a tapered waist in keeping with princely ladies' fashion in the period 1600–1625. Her hairstyle, make up, gold and pearl jewellery, as well as her fine white lace, show the Electress to have been highly conscious of fashion as an expression of social status. JCvB

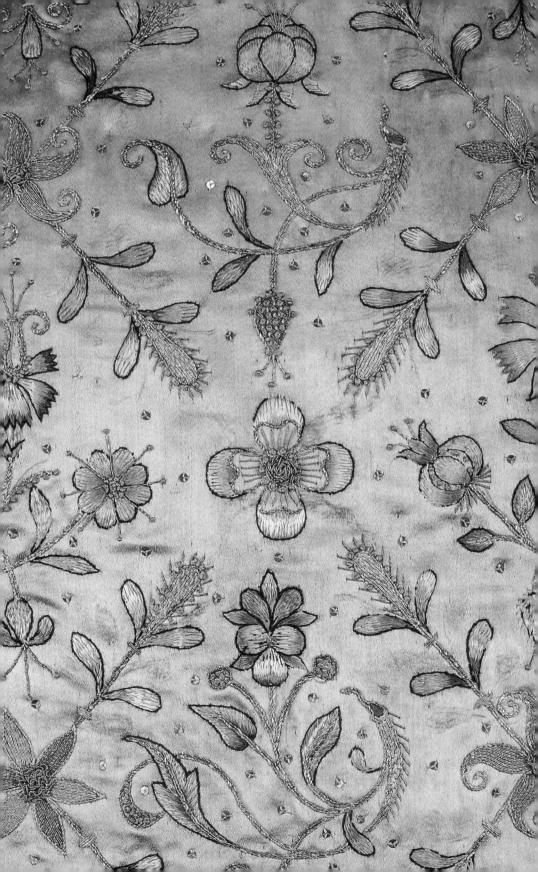

Room 4

Parade dresses, ornate saddles, and ceremonial weapons of Electors Christian II (1583–1611) and Johann Georg I (1585–1656) of Saxony

The Tower Room contains costumes, saddles, and weapons whose magnificence reflects the power and sovereignty of Electors Christian II and Johann Georg I. The cloak belonging to the "landscape dress" of Johann Georg I, made in 1611, depicts the Electoral capital on the River Elbe and is displayed in the centre of the room, in line with the axis of the tower, whose height and commanding position over the palace symbolise the ruler's dominance and represent the centre of Saxony. Exotic motifs on the items used for courtly festivities and on the precious weapon garnitures illustrate the Electors' awareness of the wider world. Hunting garments and equipment show Johann Georg I to have been a passionate huntsman. The Electors' personal tailors, the silk and beadwork embroiderer Hans Erich Friese, and the goldsmiths Michael Botza, Abraham Schwedler and Gabriel Gipfel, produced fabulous works of art to match the high ambitions of their clients. JCvB

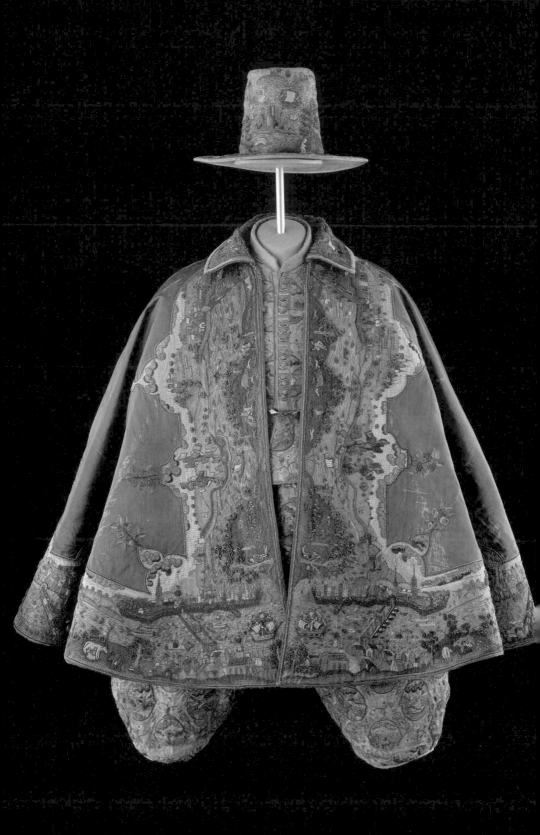

Landscape dress of Elector Johann Georg I of Saxony

Cloak
Doublet, breeches, hat, belt and sword hanger in showcase 32
1611, fabric and embroidery yarns: Italian;
tailoring: Dresden, Electoral Tailors' Workshop;
Embroidery: Hans Erich Friese, Dresden; trimmings: probably Saxon

Knee-length circular cloak with small flat collar and broad border
in pictorial embroidery; silk satin in "sea-green" (bluish green), green
(embroidery ground fabric); pictorial embroidery as relief embroidery: silk
yarns of various colours, gold and silver threads, sequins; gold braiding;
lining: greenish blue, orange-yellow, and natural-coloured silk taffeta,
gold lamé threads, lancé; embroidery border with pattern variations repeated
four times, laterally reversed on the right half of the cloak
Cloak length at front edge: 89 cm; circumference: 615.5 cm
Rüstkammer, inv. no. i. 0008

This lavish dress featuring "landscapes, wildernesses, shipping, farming, people,
and animals embroidered onto it" was a Christmas gift from the Dowager Electress
Sophia to her son Elector Johann Georg I in 1611, the year of his accession following
the sudden death of his brother Christian II. The depiction of the Elbe Valley, with
Dresden and Meissen, was intended to show the proud legacy that the new ruler
was obliged to protect and enhance.

With this cloak around his shoulders, the ruler symbolically stood at the centre
of his territory, looking down on it, just as the tower of the Palace commands an
all-round view of the electoral capital. This idea inspired the decision to exhibit the
cloak at the centre of the Tower Room. Particularly eye-catching on the front of
the cloak is the fortified electoral capital of Dresden, with the stone bridge over the
Elbe and the electoral palace, the Residenzschloss.

<div style="text-align: right">Room 4</div>

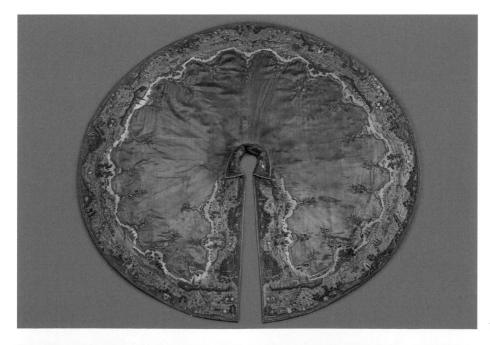

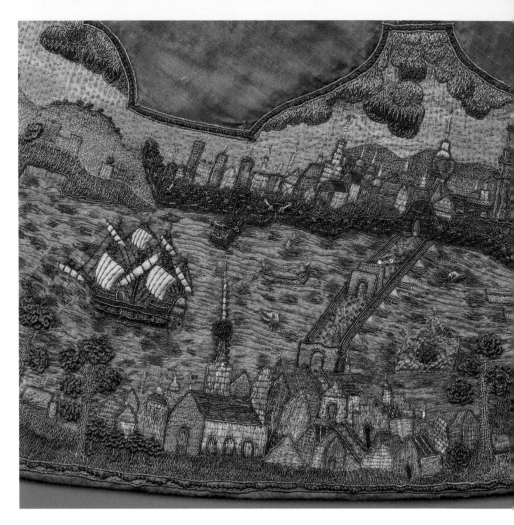

Dresden – already referred to in the sixteenth century as the other Florence, "altera florentia", or Florence on the Elbe, on account of its splendour and its location – boasts numerous towers and buildings, as well as fortifications built after Italian designs. On the walls of the fortress are shining cannons, which not only served to defend the city but also performed gun salutes to welcome princely guests, such as the Emperor Maximilian II in 1575 and the Emperor Matthias in 1617.

The Elbe Valley is shown as a fruitful natural and cultural landscape. Within the embroidered border depicting Dresden, with the district of Altendresden on the opposite bank, the river extends as far as Meissen. It flows beneath a clouded sky, past rock formations, hills, as well as groups of trees, meadows, and fields. Meissen, the old margravial capital, can be recognised by its wooden bridge and the Albrechtsburg, the castle that rises up and dominates the landscape.

The bright, silvery river busy with large ships, including the Elector's large and small personal ships, as well as rafts, barges, fisher boats and anglers, is shown as the main transport artery and the busiest body of water in Saxony. The huge fish are copied from world maps and globes. Impressive watermills are hard at work on the

tributaries. Parallel to the course of the river, roads connect the villages. Fast-moving post riders and wayfarers are seen travelling along them.

The economic success of the electoral government is convincingly demonstrated: peasant women milk cows with bulging udders. Shepherds with dogs are tending large herds. On the slopes are rows of benches for bleaching linen. The Elector on his horse presents himself in the role of master huntsman for his territory, with its rich abundance of stag, deer, and wild boar. The silk embroiderer has used the very finest materials and techniques to create a sophisticated and elaborate work of art.

A suitable occasion for Johann Georg I to present himself in this imposing outfit highlighting his sovereignty was initially delayed because of the period of mourning following the death of his brother Christian II, and also that of Emperor Rudolf II, who died in 1612. It was not until the celebrations surrounding the christening of Electoral Prince Johann Georg (II) in 1613 that it was deemed appropriate. A note regarding the cloak in the records of the Electoral Court Tailors' Workshop, written in 1613, suggests that the Elector, delighted at the birth of his new offspring, may indeed have worn it to the christening festivities. JCvB

Landscape dress of Elector Johann Georg I of Saxony

Doublet, breeches, hat, waist belt, and sword hanger
Cloak in showcase 31
1611, outer fabric and embroidery yarns: Italian;
tailoring: Dresden, Electoral Tailors' Workshop;
Embroidery: Hans Erich Friese, Dresden;
trimmings: probably Saxon
Silk satin in green, gold, and silk embroidery; gold trimmings
Rüstkammer, inv. nos. i. 0008: waist belt and sword hanger i. 0456

The doublet and breeches of "sea-green" silk satin are decorated with over
300 oval medallions connected by ribbon bows. Depicted in them are local and
distant foreign landscapes, buildings and people, ships at sea, storms and ship-
wrecks, wild animals, and sea monsters. The background is decorated with 15 floral
motifs, including carnations, strawberries, and peas.

The stiff, high hat with a wide brim and the Italian-style sword hanger are
decorated with fantastical rocky landscapes and sea motifs, as well as sailing ships
in relief embroidery on green silk satin. According to the first inventory entries, this
unique garment was accompanied by silk stockings, garters, and a hatband with
golden bobbin lace, as well as white half-boots, all in matching colours.

The motifs and technique of the embroidery done by the silk and pearl embroi-
derer Hans Erich Friese, who worked initially for Christian II and then for decades for
Johann Georg I in Dresden, are based on the English school of pictorial embroidery
promoted by Queen Elizabeth I of England and Ireland. JCvB

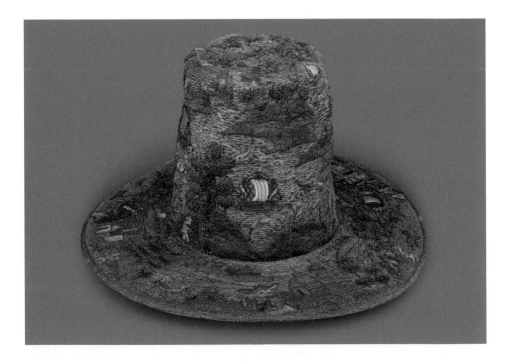

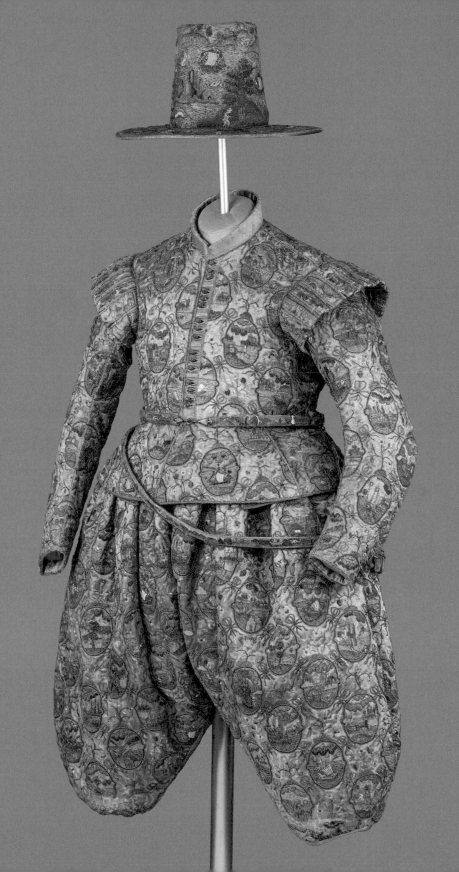

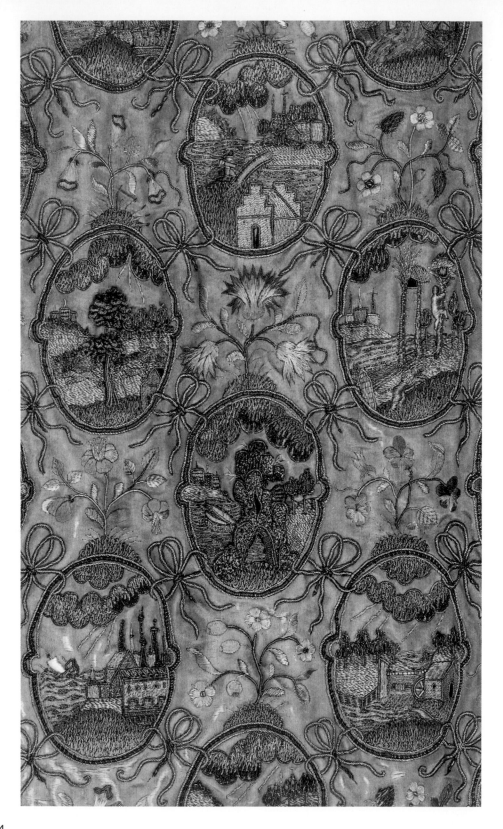

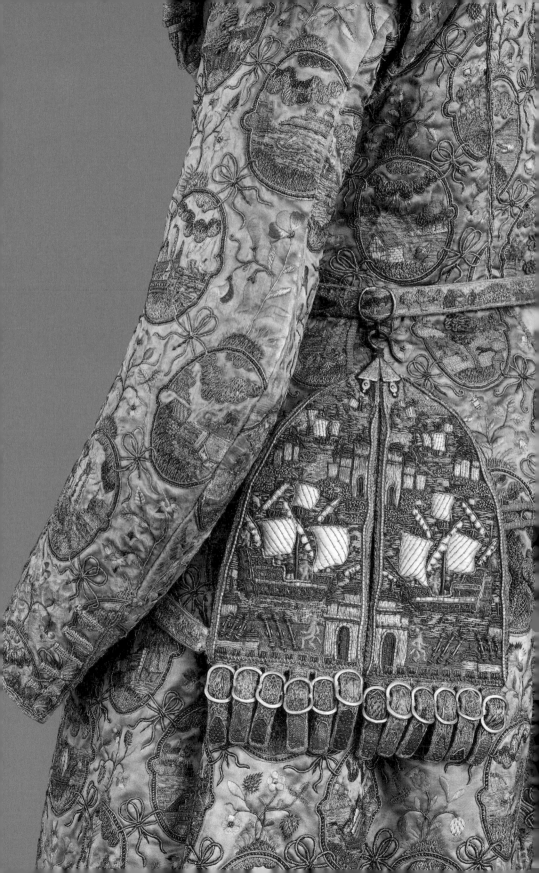

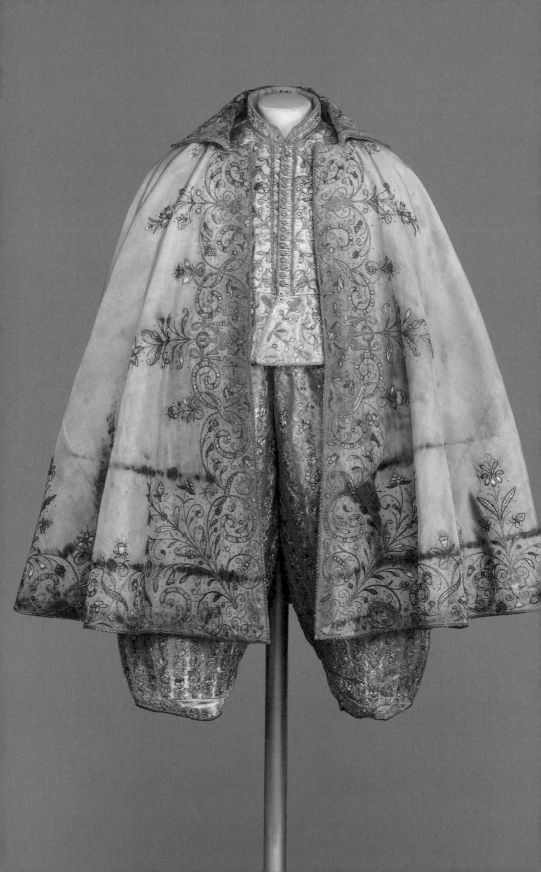

The "Parrot Green" parade dress of Elector Johann Georg I of Saxony

Cloak, doublet and breeches; pair of gloves lost since 1945
1611
Outer fabrics and embroidery yarn: Italian;
tailoring: Dresden, Electoral Tailors' Workshop;
Embroidery: Hans Erich Friese, Dresden
Cloak: yellow silk repp, gold, silver and silk embroidery;
sequins; lining: yellow silk satin "scribed"
Cloak length at front edge: 90 cm; circumference: 654 cm
Doublet and breeches: yellow-green silk satin, gold,
silver and silk embroidery; sequins; silver trimmings
Rüstkammer, inv. no. i. 0020

This "parrot green" parade dress embroidered with colourful floral motifs,
which was influenced by Italian fashion with French and Spanish elements, was
a Christmas gift from Electress Magdalena Sibylla of Saxony to her husband in
1611. (→ page 106) The Electress also had a "parrot green" dress made for herself.
Portraits of the electoral couple in the possession of the House of Wettin confirm

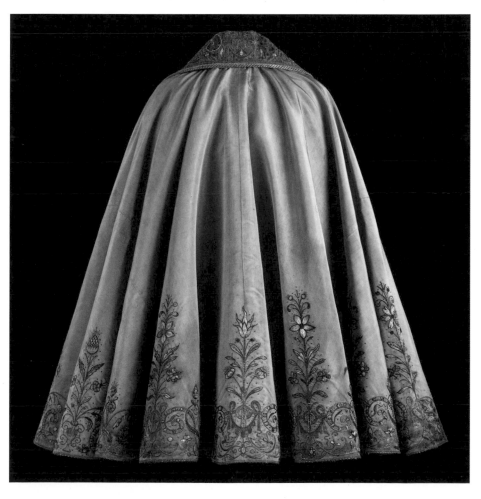

this partner look. The Spanish cloak, casually folded outwards when worn, reveals a sensational design detail on the inside: so-called "scribed" decoration consisting of floral palmettes, festoons, and strapwork (see illustration below).

The parrot green ensemble originally comprised not only the cloak, doublet, and "folded" breeches but also a jerkin (sleeveless doublet) of white leather with bows and buttons, and knee roses made of silk satin with silver lace, silk stockings, "fragrant" leather gloves with embroidered cuffs made of silk satin, and a grey "castor" (hat made of felted beaver fur) with a "sweatband". JCvB

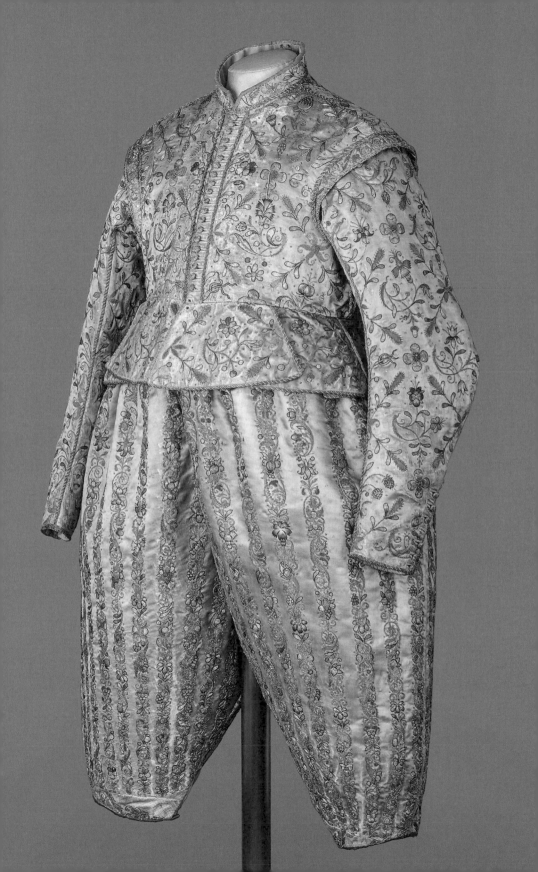

⑤

Showcase 34

Rapier-and-dagger garniture and parade textiles

German or Italian, 1st half of the 17th century
Rapier, dagger, knife ① / Pair of gloves ② / Sword hangers ③ ⑥ ⑦ /
Sword belt with waist belt and sword hanger ④ / Hunting bag ⑤
Rüstkammer, inv. nos. VI 0175, p. 0140 ① / i. 0094 ② / i. 0357 ③ /
i. 0356 ④ / X 0159 ⑤ / i. 0461 ⑥ / i. 0362 ⑦

This set of weapons, clearly intended for an adolescent, was carried by Johann Georg (I) during his Grand Tour of Italy in 1601–1602. A rapier was carried in the loops of a hanger hooked onto the left side of the waist belt. The sword hangers, gloves, and hunting bag are elaborately embroidered with coloured silk, gold and silver threads, and sequins. The ornate frame of the hunting bag ⑤ is decorated with mythical creatures and elegant tendrils in gold and coloured enamel. The sword belt "of white satin with beautiful relief embroidery in gold, silver and coloured silk thread, depicting all sorts of weaponry and munitions" ④ was given as a gift to Elector Christian II by the imperial equerry, Adam von Waldstein (Wallenstein), in Prague in 1610. VP

④

Parade saddle of Elector Johann Georg I of Saxony

Saddle and pair of holsters
Dresden, 1618
Embroidery: Hans Erich Friese
Purple silk velvet; relief embroidery: gold, silver, silk;
sequins; gold trimmings; decorative rivets;
Substructure: wood, leather, horsehair
Rüstkammer, inv. no. L 0021

On 18 October 1618, Elector Johann Georg I purchased an ornately embroidered set of horse equipment from the silk embroiderer Hans Erich Friese, of which only this saddle has survived. Exotic and native animals are naturalistically embroidered between flowers and tendrils: Deer, dromedaries, horses, goats, wolves, hunting dogs with a bear, peacocks, turkeys, and other birds. According to the inventory description, the accompanying caparison depicted the famous singer Orpheus, who enchanted animals and birds with his harp playing. The bridle, consisting of headstall, chest band, and tail strap, as well as the caparison, were sold in 1772. JCvB/VP

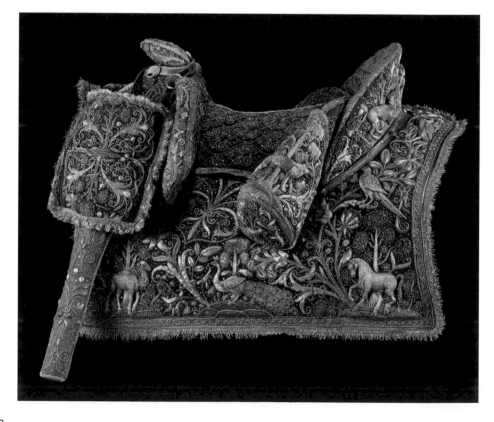

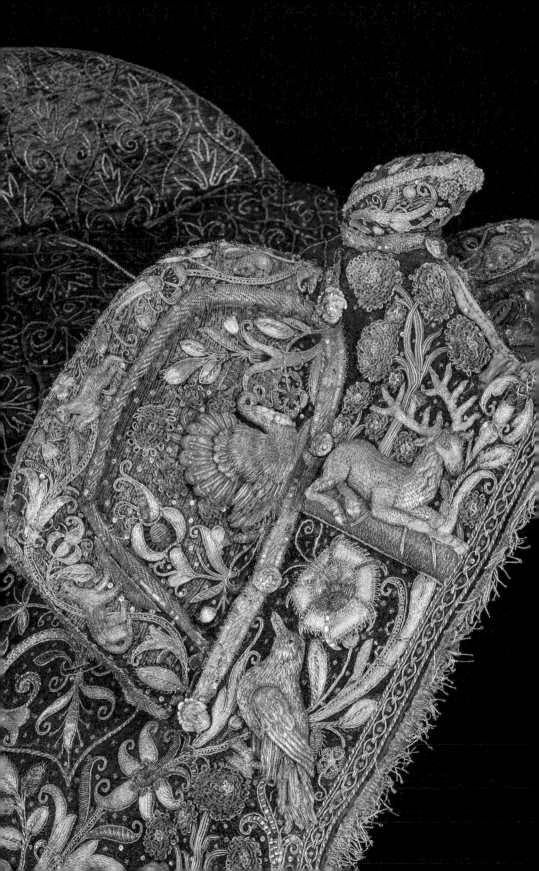

Pair of gloves depicting the Sultan (?)

Dresden, c. 1610–1620
Embroidery: Hans Erich Friese
Leather, red silk satin;
Relief embroidery: coloured silk yarn, gold and
silver thread, sequins, canetilles; gold lace;
lining: lampas, blue and yellow silk, silver wire, lancé
Rüstkammer, inv. no. i. 0093

The large medallion contains a naturalistic depiction of a Turkish man riding a white horse in a landscape featuring golden pavilions, paths, and trees. Ottoman and European war trophies fill the outer areas of both the right and left gauntlet. The embroidery motifs reflect the great fascination for the Middle East at the Saxon court. At the 1607 Carnival (Fastnacht) celebrations, Elector Christian II himself dressed up as the Sultan in a masquerade procession before the running at the ring event. JCvB/VP

Showcase 37

Hunting bag

Dresden, c. 1609
Embroidery: Hans Erich Friese
Blue-green silk velvet and silk satin; embroidery: pearls,
coloured silk yarn, gold threads, sequins; handle: iron, gilt
Rüstkammer, inv. no. X 0158

Intended for a festive hunting event, this hunting bag has a highly sophisticated design and complex structure. A white stag made of pearls is the eye-catcher on the outsides, which are decorated all over with hunting motifs in relief embroidery. Among rampant vegetation are foxes, hares, a bear, a wild boar, and a squirrel. A mounted hunter blowing his horn looks out of the opening of the main pocket. The hunting bag, which is composed of several pockets, features surprisingly delicate, colourful oriental embroidery on the concealed insides of the large pockets. Veined tulips, roses, and carnations protrude from a vase at the centre, around which are birds, insects, and squirrels. JCvB/VP

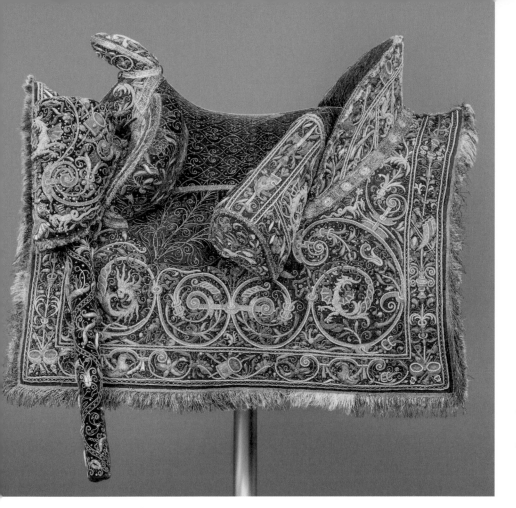

Showcase 38

Parade saddle belonging to Duke Johann Georg (I) of Saxony

Saddle and pair of pistol holsters
German, probably Dresden, 1608
Green silk velvet, gold, silver and pearl embroidery,
freshwater pearls, sequins, gold trimmings, ornamental rivets;
substructure: wood, leather, horsehair
Rüstkammer, inv. no. L 0020

This saddle, along with a pair of pistols, was given to Johann Georg (I) by his wife
Magdalena Sibylla as a Christmas gift in 1608. The elaborate pearl embroidery is
dominated by writhing dragons and exotic plants. Birds, butterflies, and squirrels are
also to be found. Strands of pearls form the volutes, flower stalks, and outlines.
The border incorporates trophies of war. VP

Parade weapons / Parade textiles / Hunting horns

Saxon, 1st half of the 17th century
Hunting swords ① ⑦ ⑧ / Rapier garnitures with sword hangers ② ⑥ /
Hunting horns ③ ④ / Wheel-lock pistol with powder flask ⑤
Rüstkammer, inv. nos. VII 0068 ① / VI 0431; i. 0413 ② / X 0195 ③ / X 0499 ④ /
J 1361; X 1192; X 1257 ⑤ / VI 0430; i. 0411 ⑥ / X 0328 ⑦ / X 0327 ⑧

Two Dresden rapier sets ② ⑥ decorated with oriental flowers, grotesques, and
equestrian figures reflect the festive tournament masquerades or pageants at
the Dresden court. The rapier, belt, and sword hanger with "Bohemian diamonds"
and pearls crafted by the goldsmith Marx Bischhausen ② were a gift from Elector
Christian II for the first wedding of his younger brother Duke Johann Georg (I) in

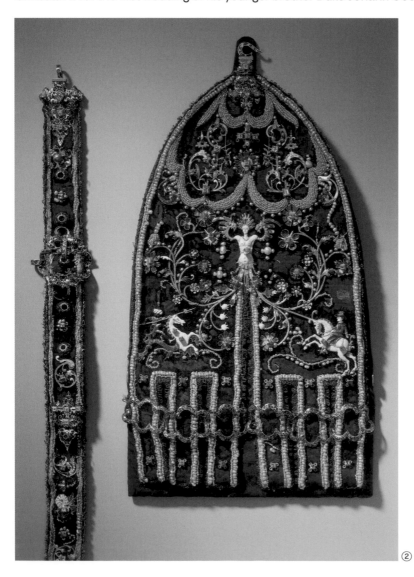

②

② →

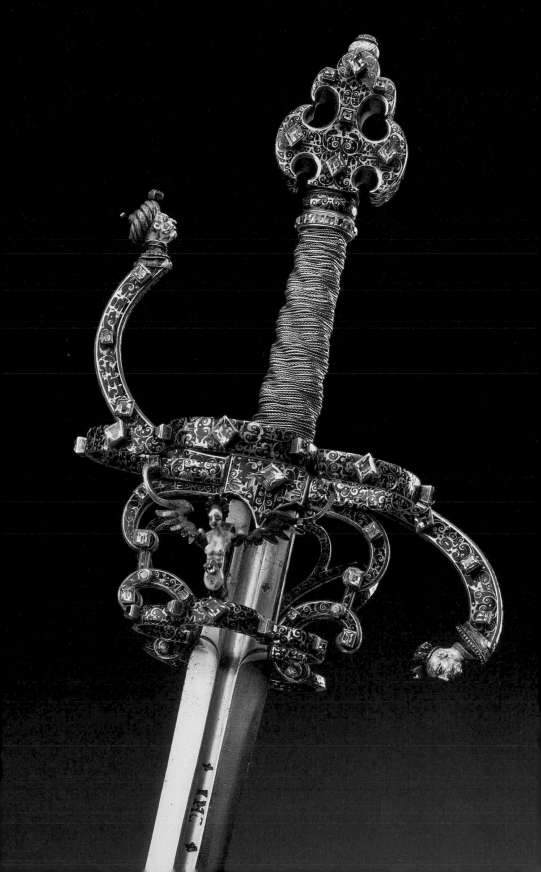

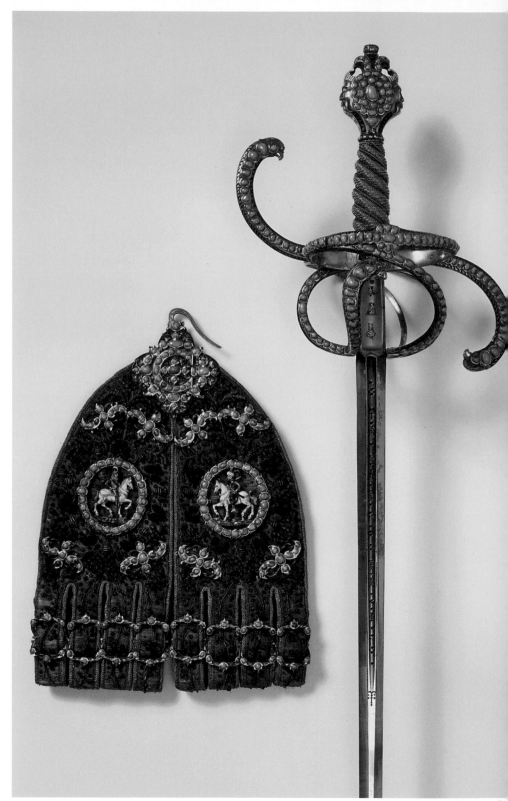

⑥

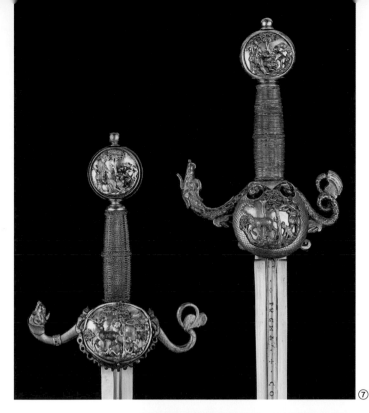

⑦ ⑧

③

1604. On the sword hanger, two cavalrymen are charging one another with lances, one riding a white sea horse and the other a white steed.

The rapier with turquoises, created by Michael Botza, was given to Christian II as a Christmas present from his mother in 1605. To go with it, Abraham Schwedler made a new sword hanger with turquoises in 1624; it depicts a European and a Middle Eastern horseman facing each other ⑥.

The pistol and the hunting horns ③ ④ are decorated with sea monsters as imagined from the descriptions of voyagers. Writhing dragons form the quillons of three swords ① ⑦ ⑧. Two of the swords with enamelled pommels and shell guard showing a bear and a stag hunt were made by Gabriel Gipfel ⑦ ⑧. One of them ⑧ was given to Johann Georg I by his wife Magdalena Sibylla as a New Year's gift in 1614. JCvB/CN

Set of hunting weapons with emeralds

Gabriel Gipfel, Dresden, 1608
Hunting hanger with scabbard and strap, eviscerating
knife with sheath and utensils, powder flask, hunting
horn with strap, belt, hunting bag, dog collar
Iron, brass, silver, gold, enamel, 194 emeralds, ivory,
green silk velvet (partly replaced), trimmings
Rüstkammer, inv. no. X 0143

This garniture is decorated with emeralds as well as hunting
scenes in colourful enamel. It cost 2,203 gulden and was
a Christmas gift from Elector Christian II of Saxony to his
brother Duke Johann Georg (I) in 1608. It bears the Elector's
coat of arms and initials "CDAHZSC" [Christian der Andere
Herzog zu Sachsen, Kurfürst/Christian the Second, Duke
of Saxony, Elector]. Johann Georg I is depicted with a hunting
garniture like this one on the frontispiece of his hunting
chronicle for the years 1611–1650. JCvB

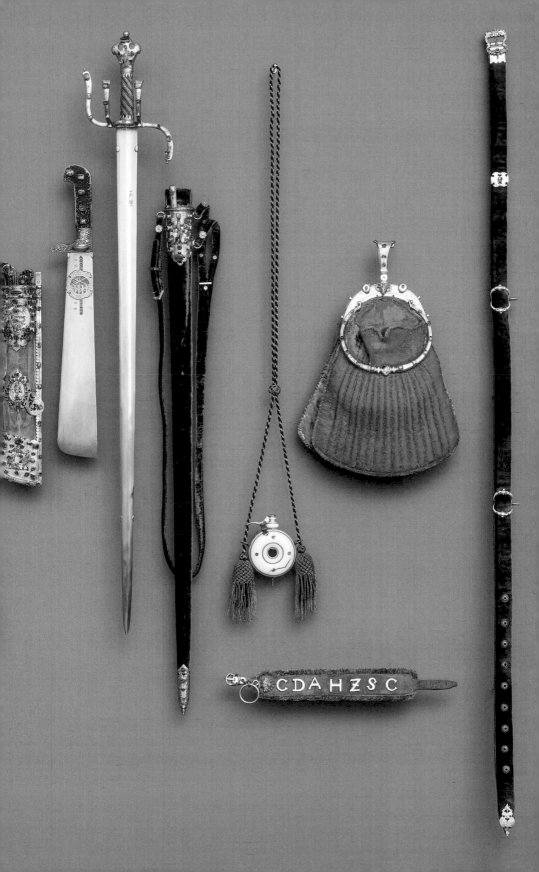

Parade dress of Elector Johann Georg I of Saxony

Doublet and breeches
1629 (?), outer fabric: Italian;
tailoring: Dresden, Electoral Tailors' Workshop
Gros de Tours liseré, grass-green silk, gold lamé
thread, lancé, gold thread brocaded; gold trimmings;
lining: green silk satin and linen
Rüstkammer, inv. no. i. 0012

With its sumptuousness and beauty, the processed silk fabric is the eye-catching feature of this ensemble of garments owned by Elector Johann Georg I of Saxony. The décor made up of flowers in gold brocade and woven decoration forming wave patterns was an early Baroque version of the scattered-flower pattern that had been rapidly growing in popularity in silk fabrics since the beginning of the seventeenth century. Gold bobbin lace, borders, and buttons emphasise the design of the outfit, which was fashionable in the first third of the seventeenth century. A portrait of Johann Georg I wearing a garment of this type appears on the frontispiece of his hunting chronicle for the years 1611–1650. JCvB

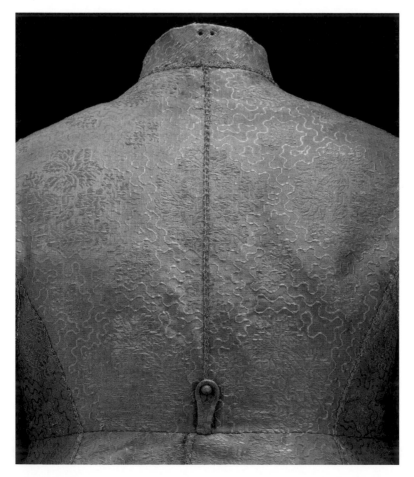

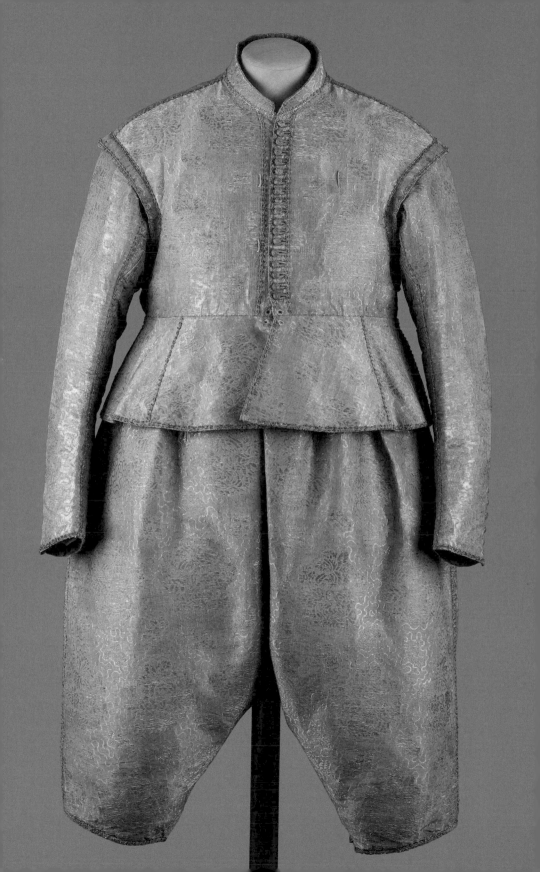

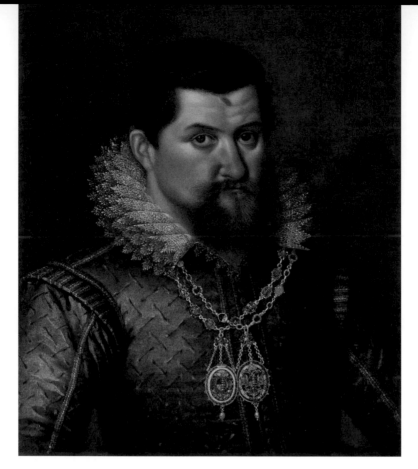

Wall exhibit 12

Elector Johann Georg I of Saxony

German, after 1611, c. 1617–1620 (?)
Oil on canvas; 63.5 × 53.5 cm
Gemäldegalerie Alte Meister, inv. no. Mo 1491 D

This bust portrait of Elector Johann Georg I wearing a decoratively slashed green silk costume and a filigree lace collar such as was fashionable in the period 1610–1620, along with two "Gesellschaftsketten" (chains with jewelled pendants), seems to have been intended for a prestigious yet personal location. This is evident, firstly, from the clothing, which lacks such features as gold edging, and also from the small format of the painting. The two chains made of gold and enamel emphasise his friendly ties with other princes and also with various followers. The Elector wears them with the pendants hanging adjacently: on the right is the "Wappengesellschaft" embellished with various coats of arms, which had been commissioned by his brother Christian II, while on the left is the "Gesellschaft mit dem kaiserlichen Doppeladler" (chain and pendant with the Imperial double eagle), which he himself commissioned upon his accession in 1611, thus declaring his loyalty to the imperial dynasty. The green garment edged in green silk may be one of the hunting costumes of Johann Georg I, who was a passionate huntsman. CN/JCvB

Hunting bag

German, 1624; outer fabrics: Italian
Yellow and green silk, gold and silver threads,
green silk velvet; trimmings; handle: silver, gilt
Rüstkammer, inv. no. X 0163

This hunting bag was probably a gift from the Bohemian nobleman Wilhelm von
Kinsky, given to Elector Johann Georg I on 16 October 1624. The gold fabric
with small flowers made of silver threads and green silk forms the front of the
hunting bag, whose three pockets are covered with green velvet. Two of the five
compartments are designed as drawstring bags. Dainty passementerie ornaments
accentuate the decoration. The handle features eye-catching angel and lion
heads, which also contain a mechanism for opening and closing the bag. VP

Room 4

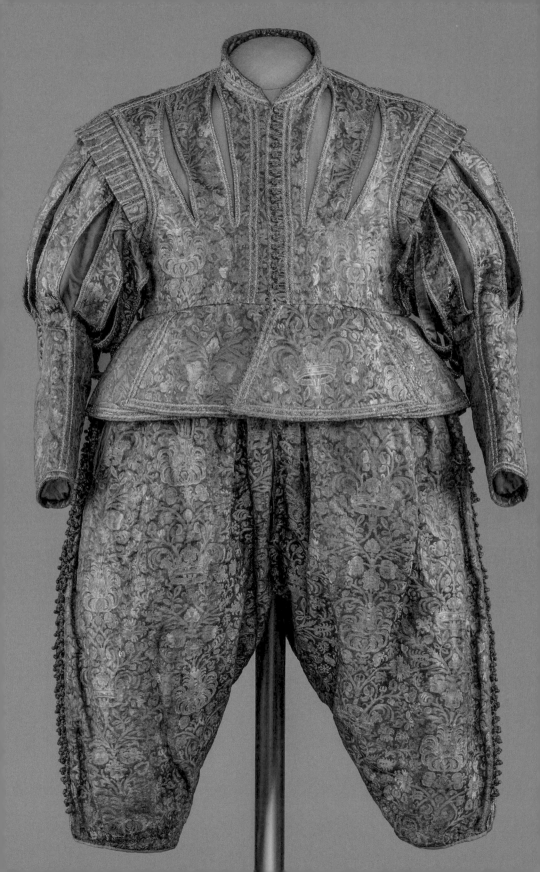

Parade dress of Elector Johann Georg I of Saxony

Doublet and breeches
c. 1620–1625; outer fabric: Italian;
tailoring: Dresden, Electoral Tailors' Workshop
Lampas, green, yellow, white, beige and salmon-pink, silk,
gold wire, lancé; gold trimmings; lining: green silk satin
and green taffeta, linen
Rüstkammer, inv. no. i. 0011

This parade dress consisting of a doublet and breeches is made of a brocade-like gold fabric. It was evidently intended as a prestigious status symbol, not only on account of its lavish material but also in view of its décor. On a green silk background are repeating patterns incorporating large golden crowns in a network of golden tendrils and flowers with salmon-pink, white, and yellow accents. A garment of this quality was worn by Johann Georg I when Emperor Matthias processed into Dresden in 1617. The style of the doublet, with slits in the sleeves down to the elbow and at the chest and back up to the armpit, points more to this garment having been made in the 1620s, when these features were typical of French men's fashion, which was on the advance. During the Thirty Years' War, it became a trademark of the protagonists of the Protestant side, who saw France as a potential ally, since it was the main opponent of the Emperor and the King of Spain. The beltline of this type of doublet gradually shifted up above the waist, shortening the bodice section of the doublet and lengthening the laps, as evidenced by original garments and portraits of King Gustav II Adolf of Sweden (Livrustkammeren Stockholm).

The doublet of Johann Georg I exhibited here is still at the beginning of this development. The slits are enhanced with gold edging. Several rows of small gold passementerie buttons and borders embellish the sleeves, the front and back of the doublet, as well as the side seams of the comfortably cut breeches that reach down to just above the knee. The breeches were fastened to the doublet by means of hooks and eyes, concealed by the laps.

The Elector had a second, similar parade dress made from the same exquisite fabric that was used for the garment shown here. The slits on that dress could be worn open, or they could be closed with gold passementerie buttons. When buttoned up, the dress looked less French. The Protestant Elector of Saxony, who saw himself as a mediator and sided with the Catholic Emperor, was able to turn this to diplomatic advantage in a very practical way.

In a silver relief by Sebastian Dattler dating from 1630 (Grünes Gewölbe), both Johann Georg I and Electoral Prince Johann Georg (II) are depicted wearing garments in the style of this dress. After the Imperial Edict of Restitution in 1629, which was directed against the provisions of the Peace of Augsburg of 1555, Johann Georg I began to contemplate an alliance with Sweden and the Electorate of Brandenburg. JCvB

Room 4

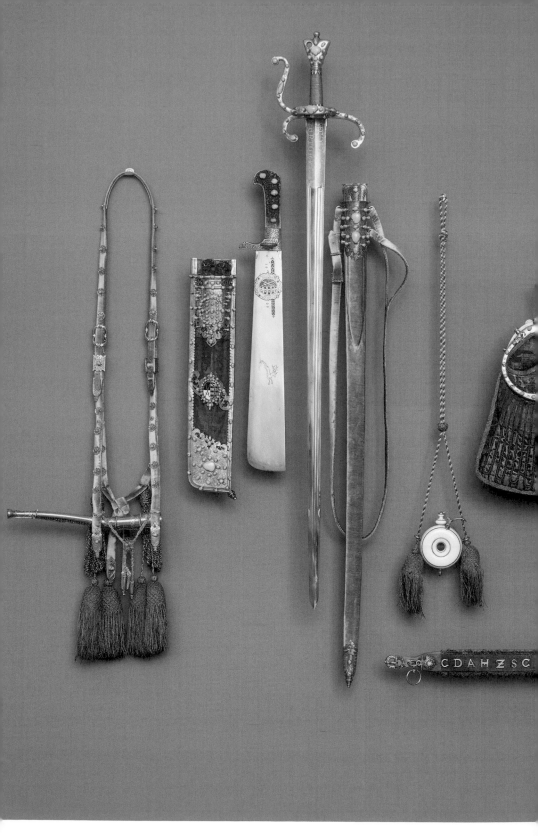

Set of hunting weapons with turquoises

Gabriel Gipfel, Dresden, 1606–1607
Hunting hanger with scabbard and strap, eviscerating knife
with sheath and utensils, powder flask, belt, hunting horn
with strap, hunting bag, dog collar
Iron, brass, silver, gold, enamel, 336 turquoises, ivory,
black and white "chequered" silk velvet (partly replaced),
trimmings
Rüstkammer, inv. no. X 0144

This set of hunting weapons represents the basic equipment of
an aristocratic huntsman. It was a Christmas present from Elector
Christian II of Saxony to his brother Duke Johann Georg (I) in 1607
and bears the Elector's coat of arms and initials. The set, which
originally featured 439 turquoises, cost 2,000 thalers. Some elements
are now missing, including the hat band with 98 turquoises. The
powder flask was needed for the firearms that were indispensable
for the hunt. JCvB

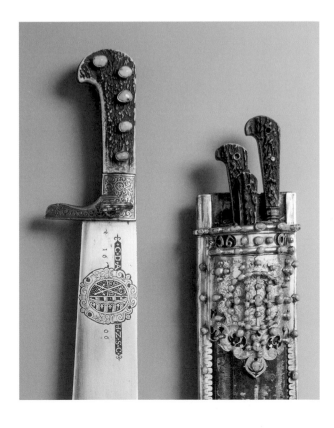

Room 4

Bibliography

Jutta Bäumel, Das Prunkkleid des Kur-fürsten Johann Georg I. von dessen Bildnis in der Jagdchronik aus dem Jahre 1647, Kunstwerk des Monats in der Rüstkammer, in: Dresdener Kunst-blätter 43, no. 4 (1999), pp. 131–140

Jutta Bäumel, Der Kleidernachlass des Kurfürsten Moritz von Sachsen, in: Das Inventar von 1553 und die in der Dresdner Rüstkammer überlieferten Inventare, in: Waffen- und Kostüm-kunde 35, no. 1–2 (1993), pp. 65–106

Jutta Bäumel, Ein festliches Jagdkleid, Kunstwerk des Monats in der Rüst-kammer, in: Dresdener Kunstblätter 39, no. 3 (1995), pp. 87–91

Jutta Bäumel, Ein Kurfürst als bunter Vogel – Das "sittichgrüne" Prunkkleid für Johann Georg I. von Sachsen zu Weihnachten 1611, Kunstwerk des Monats in der Rüstkammer, in: Dresdener Kunstblätter 48, no. 6 (2004), pp. 418–419

Jutta Bäumel, Eine Jagdtasche mit Bild- und Perlenstickerei der Spätrenais-sance, Kunstwerk des Monats in der Rüstkammer, in: Dresdener Kunst-blätter 44, no. 4 (2000), pp. 125–133

Jutta Bäumel, Fürstliche Kleidung, Ein-führung, in: In fürstlichem Glanz. Der Dresdner Hof um 1600, edited by Dirk Syndram/Antje Scherner, exhibition catalogue Museum für Kunst und Gewerbe Hamburg/Staatliche Kunstsammlungen Dresden, Milano 2004, pp. 111

Jutta Bäumel, Kleidung und Ausstattungen zu den Hochzeiten des Herzogs Johann Georg (I.) von Sachsen 1604 in Dresden und 1607 in Torgau, in: Jahrbuch der Staatlichen Kunst-sammlungen Dresden 24 (1993), pp. 25–32

Jutta Bäumel, Kurfürstliche Kleider für Vater, Sohn und Tochter? Kunstwerk des Monats in der Dresdener Rüst-kammer, in: Dresdener Kunstblätter 37, no. 1 (1993), pp. 34–35

Jutta Bäumel, Rüstkammer. Führer durch die ständige Ausstellung im Semper-bau, Munich/Berlin 2004

Jutta Bäumel, Silk-knit costume in the possession of the Electors Moritz and Augustus of Saxony. A contribution to princely knitted clothing in the sixteenth century, in: Stichting Textiel-commissie Nederland, Gebreid Goed, Textildag gehouden in het Instituut Collectie Nederland te Amsterdam op 23 april 1998, pp. 5–22

Jutta Bäumel, The collection of Electoral and royal costumes in the Dresden Rüstkammer/"Wore a white dress of silver cloth ..." – of princely bride-grooms' costumes, in: Modelejon. Manligt Mode 1500-tal 1600-tal 1700-tal [Lions of Fashion, Male fash-ion of the 16th, 17th, 18th centuries], edited by Lena Rangström, The Royal Armoury, Livrustkammaren Stockholm 2002, pp. 285–286/pp. 375–377

Jutta Bäumel/Gisela Bruseberg, Das Bräutigamskleid Herzog Augusts von Sachsen aus dem Jahre 1548, in: Jahr-buch der Staatlichen Kunstsammlun-gen Dresden 21 (1989/1990), pp. 7–24

Jutta Bäumel/Gisela Bruseberg, Eine gestrickte Seidenhose des Kurfürsten August von Sachsen – unikaler Beleg für die fürstliche Strickmode im 16. Jahrhundert, in: Jahrbuch der Staat-lichen Kunstsammlungen Dresden 22 (1991), pp. 7–14

Jutta Bäumel/June Swann, Die Schuh-sammlung in der Dresdner Rüstkammer, in: Waffen- und Kostümkunde 38, no. 1–2 (1996), pp. 1–33

Jutta Charlotte von Bloh, Elbflorenz in Gold und Seide – Die Darstellung Dresdens und des Elbtals auf dem Prunkkleid des Kurfürsten Johann Georg I. von Sachsen vom Jahre 1611, in: Der Blick auf Dresden. Die Frauenkirche und das Werden der Dresdner Stadtsilhouette, edited by Anna Greve/Gilbert Lupfer/Peter Plaßmeyer, exhibition catalogue Staatliche Kunstsammlungen Dresden/Munich/Berlin 2005, pp. 42–50

Jutta Charlotte von Bloh, Kleidung und Waffe in den Fürstenbildnissen der Cranachs, in: Cranach, Gemälde aus Dresden, edited by Harald Marx/Ingrid Mössinger, exhibition catalogue Kunstsammlungen Chemnitz, Chemnitz und Bonn 2005, pp. 174–181

Jutta Charlotte von Bloh, The Triumph of the Rapier in the Armoury of the Prince Electors of Saxony, in: The Noble Art of the Sword, Fashion and Fencing in Renaissance Europe 1520–1630, edited by Tobias Capwell, exhibition catalogue The Wallace Collection, London 2012, pp. 202–217

Max von Ehrenthal, Führer durch das königliche historische Museum, Dresden 1899

Erich Haenel, Hofkleider Johann Georgs I. im Historischen Museum zu Dresden, in: Mitteilungen aus den sächsischen Kunstsammlungen 2 (1911), pp. 41–53

Erich Haenel, Kostbare Waffen aus der Dresdner Rüstkammer, Leipzig 1923

Christine Nagel, Die Gesellschaften der sächsischen Kurfürsten, in: Dresdner Geschichtsbuch, ed. by Stadtmuseum Dresden 13 (2008), pp. 53–75

Christine Nagel, Meisterwerke der Juwelierkunst – Drei Wehrgehänge aus dem Besitz des Kurfürsten Johann Georg I. von Sachsen aus den Jahren 1617 und 1624 in der Dresdner Rüstkammer, in: Waffen- und Kostümkunde 56, no. 2 (2014), pp. 169–186

Jutta Nicht, Historische Prunkkleidung, Dresden 1963

Bettina Niekamp/Agnieszka Woš Jucker, Das Prunkkleid des Kurfürsten Moritz von Sachsen (1521–1553) in der Dresdner Rüstkammer, Restaurierung – Dokumentation – Konservierung, with contributions by Jutta Charlotte von Bloh/Anna Jolly, Riggisberger Berichte 16, Abbegg-Stiftung Riggisberg 2008

Dieter Schaal/Heinz-Werner Lewerken/Elfriede Lieber/Holger Schuckelt, Vermisste Kunstwerke des Historischen Museums Dresden, edited by Staatliche Kunstsammlungen Dresden, Dresden 1989

Schätze einer Fürstenehe. Die Hochzeit 1607 in Torgau und das reiche Vermächtnis des Kurfürstenpaares Johann Georg I. und Magdalena Sibylla von Sachsen, Dresden 2016

Johannes Schöbel, Prunkwaffen. Waffen und Rüstungen aus dem Historischen Museum Dresden, Berlin 1973

Erna von Watzdorf, Kursächsische Jagdwaffen von Gabriel Gipfel in der Dresdner Rüstkammer, in: Zeitschrift für Historische Waffen- und Kostümkunde 14, no. 1 (1935–1936), pp. 4–14

Zabytkowe stroja oraz akcesoria z XVI–XVIII w. ze zbiorów Muzeum Historycznego w Dreźnie, Wroclaw 1980

Imprint/Image credits

Imprint

Published by: Staatliche Kunstsammlungen Dresden, Rüstkammer, Marius Winzeler

Introductory texts: Jutta Charlotte von Bloh, Christine Nagel, Marius Winzeler
Object texts: Jutta Charlotte von Bloh (JCvB), Christine Nagel (CN), Viktoria Pisareva (VP)
Translation: Geraldine Schuckelt
Editing: Jutta Charlotte von Bloh, Christine Follmann, Christine Nagel, Viktoria Pisareva
Photo editing: Christine Nagel, Viktoria Pisareva, Susanne Sonntag
Project management publishing house: Imke Wartenberg
Production publishing house: Stefanie Kruszyk
Series layout, cover design, typesetting: Kathleen Bernsdorf, Berlin
Image editing: bildpunkt Berlin
Printing and book binding: Beltz Grafische Betriebe GmbH, Bad Langensalza

The Deutsche Nationalbibliothek (German National Library) lists this publication in the Deutsche Nationalbibliografie (German National Bibliography); detailed bibliographic data is available on the internet at http://dnb.dnb.de.

© 2023 Deutscher Kunstverlag
www.deutscherkunstverlag.de
An Imprint of Walter de Gruyter GmbH Berlin Boston
www.degruyter.com

ISBN 978-3-422-80137-0